GREEK SCULPTORS
AT WORK

PHAIDON

GREEK
SCULPTORS
AT WORK

BY CARL BLUEMEL

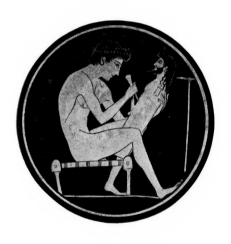

PHAIDON

FIRST GERMAN EDITION 1927

FIRST ENGLISH EDITION 1955

SECOND ENGLISH EDITION 1969

PHAIDON PUBLISHERS INC., NEW YORK

DISTRIBUTORS IN THE UNITED STATES: FREDERICK A. PRAEGER INC.

111 FOURTH AVENUE, NEW YORK, N.Y. 10003

LIBRARY OF CONGRESS CATALOG CARD NUMBER: 77-81234

TRANSLATED BY

LYDIA HOLLAND

REVISED BY

BETTY ROSS

SBN 7148 1359 1

MADE IN GREAT BRITAIN

PRINTED BY R. MACLEHOSE & CO. LTD., UNIVERSITY PRESS, GLASGOW

LIST OF ILLUSTRATIONS

Title-page. Man carving a Herm, inner surface of a cup, attributed to the vase painter Epictetus, about 510 B.C. 8 cm. (3⅛ in.) diameter. Copenhagen, National Museum. *Corpus Vasorum Antiquorum, Denmark*, Vol. 3, pl. 139, 2b.

1. Stele of Mynno. h. 59 cm. (23¼ in.). After 430 B.C. Berlin Museum, no. 737. Photograph, Schwarz.

2-4. Statue of colossus, Naxos. l. 10.45 m. (34 ft. 3 in.). Sixth century B.C.

5. Statue of a youth, Naxos. l. 5.55 m. (17 ft. 2 in.). Sixth century B.C. Photograph, Archaeological Institute of Athens.

6-8. Man with Ram, Thasos. h. 3.5 m. (11 ft. 6 in.). Early sixth century B.C. Photograph, Ecole Française in Athens.

9. Fragment of a statuette with horse and rider, Sparta. h. 20 cm. (7⅞ in.). Sixth century B.C. London, British Museum, no. B. 476.

10. Statue of a youth from Mount Pentelicus. h. 2.10 m. (6 ft. 11 in.). Sixth century B.C. Mélanges Nicole, 401, Pl. I.

11. Statuette of a youth from Mount Pentelicus. h. 48 cm. (19 in.). Sixth century B.C. London, British Museum, no. B. 472.

12-13. Male torso from Naxos. h. 1.02 m. (3 ft. 4 in.). Sixth century B.C. Athens, National Museum, no. 14. Photograph, author.

14. Torso of a youth from Naxos. h. 1.11 m. (3 ft. 8 in.). Sixth century B.C., Berlin Museum, no. 1555. Photograph, Treue.

15. Votive relief with sculptor's point and mallet. h. 35.6 cm. (14 in.). New York, Metropolitan Museum of Art, *Bulletin 21*, 1926, 260, Pl. 6.

16. Sculptor's tools.

17. Kneeling handmaiden (O) from the east pediment at Olympia. h. 1.15 m. (3 ft. 9 in.). About 460 B.C. Olympia, Museum. Photograph, Excavation Committee.

18. Back view of a naked, bending man. First half of the fifth century B.C. Athens, National Museum, no. 2324. Photograph, Archaeological Institute, Athens, N.M. 1170.

19. Male torso, fake. Private collection, England.

20-21. Head of a youth. h. 14.2 cm. (5⅝ in.). Sixth century B.C. Munich, Glyptothek, no. 48. Photographs, author.

22. Head of Apollo from the west pediment at Olympia. h. 44 cm. (17 in.). About 460 B.C. Olympia, Museum. Photograph of a cast, author.

23-24. Head of a youth from the Delion on Paros. h. 15 cm. (6 in.). About 480 B.C. Paros, Museum. Photographs, Wagner.

25–26. Head of a youth from the Asklepieion, Paros. h. 15 cm. (6 in.). About 480 B.C. Paros, Museum. Photographs, Wagner.

27. Red-figured hydria with the myth of Danaë. About 500 B.C. Boston, Museum of Fine Arts, no. 13.200.

28. Red-figured jug from Athens, with Athena as sculptress. h. 21.5 cm. (8½ in.). After 470 B.C. Attributed to the so-called Pan Painter. Berlin, Antiquarium, F 2415. Photograph, Schwarz.

29–30. Clay mould of an enthroned goddess, Tarentum, with cast (slightly enlarged). h. 11 cm. (4⅜ in.). Fifth century B.C. Berlin, Antiquarium, no. 30990. Photographs, Schwarz.

31–32. Clay mould and cast of youth, Tarentum. h. 14 cm. (5½ in.). Fourth century B.C. Berlin, Antiquarium, no. 31114. Photographs, Schwarz.

33. Gem with sculptor using plumb-line before a Herm. Size 13.1 mm. (about ½ in.). New York, Metropolitan Museum of Art. G. M. A. Richter, *Catalogue of Engraved Gems*, 72, no. 89, pl. 29.

34. Gem with sculptor modelling a bust. Size 13.1 mm. (about ½ in.). New York, Metropolitan Museum of Art. G. M. A. Richter, *Catalogue of Engraved Gems*, 84, no. 118, pl. 33.

35. Gem with sculptor with plumb-line before his model. Size 19.4 mm. (¾ in.). Collection at Gotha.

36. Statue of a youth from the Island of Rheneia. h. 1.75 m. (5 ft. 8 in.). First century B.C. Athens, National Museum, no. 1660. Photograph, Archaeological Institute, Athens, no. 365.

37. Head of a bearded man (L) from the east pediment at Olympia. h. 37 cm. (14½ in.). About 460 B.C. Olympia, Museum. Photograph of cast, author.

38. Head of a Lapith (Q) from the west pediment at Olympia. h. 36.5 cm. (14⅜ in.). About 460 B.C. Olympia, Museum. Photograph, Hamann.

39. Head of an old woman (B) from the west pediment at Olympia. h. 34 cm. (13½ in.). Copy, Roman imperial period. Olympia, Museum. Photograph, Hamann.

40. Head of Herakles from the lion metope at Olympia. About 460 B.C. Olympia, Museum. Photograph, Hamann.

41. Male torso from Athens. h. 35 cm. (13¾ in.). First century A.D. Berlin, Museum, no. 519. Photograph, Schwarz.

42. Diagram of measuring method with plumb-line.

43. Dionysos with Satyr. h. 71 cm. (28 in.). Copy, Roman imperial period from a fourth-century B.C. original. Athens, National Museum, no. 245. Photograph Alinari, 24233.

44, 46. Male torso. h. 52 cm. (20½ in.). About 480 B.C. Museum on Aegina. Photograph, author.

45, 47. Torso of a youth. h. 85 cm. (2 ft. 9½ in.). Copy, Roman imperial period from an original of the fifth century B.C. Athens, National Museum, no. 1624. Photograph, author.

48. Torso of an athlete unlacing his sandal. h. 75 cm. (29½ in.). Copy, Roman imperial period, from an original of the School of Lysippos, fourth century B.C. Athens, Acropolis Museum, no. 1325. Photograph, Archaeological Institute, Athens.

49. Head of a woman, Athens. h. 33 cm. (13 in.). After 440 B.C. Berlin Museum, no. 607. Photograph, Schwarz.

50. Female bust from Island of Rheneia. h. 57 cm. (22 in.). First century B.C. Athens, National Museum, no. 779. Photograph, author.

51. Head of a youth. h. 23 cm. (9 in.). Roman imperial period. Athens, National Museum, no. 642. Photograph, Archaeological Institute, Athens. AV 180a.

52. Lion-head waterspout from the Temple of Zeus at Olympia. h. 53.5 cm. (21 in.). About 460 B.C. Berlin, Pergamon Museum. Photograph, Schwarz.

53. Lion-head waterspout from the Temple of Zeus at Olympia. h. 48 cm. (19 in.). Copy, Roman imperial period. Berlin, Pergamon Museum. Photograph, Treue.

54. Group of two men, one standing and one kneeling in front of him, height of fragment 49 cm. (19¼ in.). Erechtheion frieze. Last quarter of the fifth century B.C. Athens, Acropolis Museum, no. 1073. Photograph, Archaeological Institute, Athens.

55. Relief from the Telephos frieze, Pergamon. h. 1.58 m. (5 ft. 2 in.). Second century B.C. Berlin, Pergamon Museum. Photograph, Berlin Museum.

56. Relief with warrior, Naukratis. h. 36 cm. (14¼ in.). Sixth century B.C. London, British Museum, B. 437.

57. Relief from the small frieze of Nereid monument, Xanthos. Second half of fifth century B.C. London, British Museum, no. 908. Photograph, Mansell 2154.

58. Votive relief with the two Dioscuri, Athens. h. 37 cm. (14½ in.). Fourth century B.C. Berlin Museum, no. 730. Photograph, Treue.

59. Horseman from the Parthenon frieze. h. of relief panel 1 m. (3 ft. 3 in.). About 440 B.C. London, British Museum.

60. Attic grave vase. h. 2.12 m. (6 ft. 11½ in.). After 440 B.C. Athens, National Museum, no. 835. Conze, *Die attischen Grabreliefs II*, no. 1047, pls. 218–19.

61. Gem with artisan using a running drill. London, British Museum, no. 305. Middleton, *The Engraved Gem of Classical Times*, 105, pl. 21. Photograph, British Museum.

62. Rider from Breitfurt an der Blies, h. 2.85 m. (9 ft. 4 in.). Fourth century A.D. Hildenbrand, *Der römische Steinsaal des historischen Museums der Pfalz zu Speyer*, p. 21, no. 1, pl. 11.

63. The Coronation of the Virgin. School of Orcagna. h. 50 cm. (19¾ in.). Four-teenth century. Orvieto, Opera del Duomo. Photograph, Homann-Wedeking.

64. Woman with column. School of Orcagna. h. 60 cm. (23⅝ in.). Fourteenth century. Orvieto, Opera del Duomo. Photograph, Homann-Wedeking.

65. Tympanum relief: Christ between the Virgin and St. John. East choir, Naumburg Cathedral. Thirteenth century. Photograph, Kirsten.

66. Relief: Annunciation, Nativity and Adoration of the Shepherds. h. 69 cm. (2 ft. 3 in.). Early fourteenth century. Pisa, Museum. Photograph, Florence Institute of History of Art.

67. Relief: Allegory of Faith. Attributed to Mino da Fiesole (1431–84). h. 1.30 m. (4 ft. 3 in.). Berlin, Kaiser Friedrich Museum, no. 167. Photograph, Schwarz.

GREEK SCULPTORS AT WORK

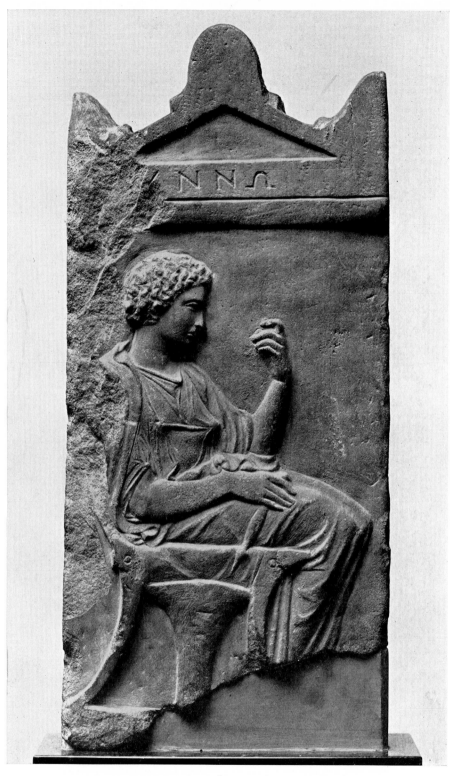

1. STELE OF MYNNO. After 430 B.C. Berlin, Museum

GREEK SCULPTORS AT WORK

IN THE PERIOD when the Erechtheion was being built upon the Acropolis and the Parthenon had recently been completed, a sculptor whose name has not come down to us, but who had had his share in creating the masterpieces of Greek sculpture in the Athens of Pericles, was commissioned to carve a modest grave relief (1). In the city below, Mynno had died and had been buried by the side of the road which led down to the Piraeus. Her relatives could not afford to erect a costly monument in her memory; for this reason it is only 2 feet high. The pediment was left plain for the same reason, depending for its ornamentation and design on paint now unfortunately faded. The relief, which has no border, represents the dead maiden at her household tasks. She is seated beside a basket of wool and holds a spindle in her right hand; the distaff, which one would expect to see in her upraised left hand, must only have been painted in. She gazes calmly ahead, deeply absorbed in her work. She has short hair and wears the customary garments, a chiton with girdle and an himation draped over it. The remains of her name, along the upper edge of the relief, must be completed as 'Mynno'. Since the name of her father or husband was not added, Mynno cannot have been a free woman. She was a slave or poor waif. But even so she was given a grave relief which, in its simple humanity, peacefulness and calm serenity, can take its place alongside the figures of the Parthenon frieze. It would be difficult to find in history any other people among whom even a serving-maid would be given a memorial of such nobility, nor any period of art in which a stele such as Mynno's would exemplify a low level of sculptural ability. This diffusion of art throughout a whole people and in every class, to an extent that has never again been equalled, presupposes an extremely high standard of technical accomplishment. It is therefore worth our while to discover all we can concerning the

methods of Greek sculptors and to find out in what way they differed from those of later artists.

How can we today, after a lapse of 2,500 years, find out how a Greek sculptor worked? Ancient writers tell us nothing. What sculptors, such as the great Polycletus in the fifth century B.C., themselves wrote has unfortunately been lost, and anything else upon the subject in ancient literature was not written by experts but by historians and men of letters. It is usually anecdotal and intended only for the layman, so that practically nothing can be learnt from it. Occasional information in inscriptions and representations of sculptors at work are important. But the sculptures themselves remain the chief source, above all those on which tool marks are still visible and have not been effaced by the careful smoothing of the surface. We must learn to see how the various tools were used on the actual sculptures, and to link this with what we assume to have been the sculptor's methods. This is not a difficult task, since the same few tools are employed today as in the past. The successive stages of work, however, and the use to which the various tools are put, were different. Every period has its own way of seeing and representing form, and technical methods have always been directly dependent upon the contemporary view of form. The variety of possible methods of modelling corresponds in sculpture to the great versatility of the few main types of tool. The relics of ancient sculpture enable us to observe these methods at different periods and in different stages of work over such a wide field that we obtain a fairly clear view of the main lines of development and practice followed throughout the centuries. In addition the steady, uniform technical tradition among the Greeks permits us, when we can follow part of the genesis of one work, to draw conclusions applicable to other, similar works of the same period. General rules may, nevertheless, be laid down only with due caution, since occasional deviations and variations are always to be reckoned with, if only because different works may vary in quality. Moreover, not only every school, but every studio develops special technical peculiarities through its own experience and in relation to the material in use. But here we are not concerned with such

minutiae, whose enumeration would become tedious through sheer weight of detail. What matters is to obtain an overall idea of the various stages of works of sculpture, during the different periods of Greek art, from the earliest rough-out in stone to the state of final completion.

In the first place, there are many pieces which an artist abandoned before they were finished. These are the waste products of ancient sculpture, but this does not mean that they always come from the hand of the worst sculptors. Often, after weeks and months of labour, the marble reveals an inner flaw which was not detectable at the quarry. Cracks suddenly appear, for instance, or brittle patches which flake off and render further labour fruitless. On other occasions it may have been external events which prevented completion. A place like Delos, for example, would be destroyed in war, its population deported, and the sculptor's workshop left deserted, while the work he had begun gradually became covered with soil, only coming to light once more through present-day excavations. Some pieces were never completed because the sculptor died and there was no one else able to carry the task through to its end. An undoubtedly rare occurrence, but the first to leap to mind when speaking of an unfinished sculpture, is that the sculptor abandoned his work upon discovering that he had ruined the block. Naturally every stone-mason makes an occasional error, but there are so many ways of making good such damage that it can usually be overcome with a certain amount of skill. For it is only in the early stages of work, when the sculptor is breaking away larger fragments from his block, that he can go badly wrong. At this point, there are still many ways of retrieving the situation; whereas at a more advanced stage of work it is hardly possible to mis-direct a blow or to split off too large a piece of the stone.

Equally instructive are those sculptures on which only some areas were left unfinished because they would not be visible after the work was finally in place. These sections are rarely left completely rough; the sculptor merely sought to avoid laborious detail work and smoothing. The boundary between what is and what is not finished is never clearly defined because, in changing over to a finer tool, the sculptor never

resumes work at exactly the same place in the transitional area. Thus these parts often present a cross-section of the final and most important stages of work. But even on finished sculptures tool marks are not always completely effaced, and even where only little is to be seen, this often suffices to provide a connection with earlier stages in unfinished works using the same technique.

N E A R the most northerly point of the Island of Naxos, in the neighbourhood of the village of Komiaki, an unfinished colossal statue of a bearded Greek god lies in an ancient quarry on the slope of a hillside (2–4). It must be visualized standing upright, the left foot slightly forward, both arms pressed close to the body as far as the elbow. The fore-arms extend straight ahead. Only the broad outlines of the drapery have been roughed out. The eyes are slightly hollowed out, the nose is indicated by a broad, flat ridge. Several deep cracks appear across the head and chest; they may explain why the statue was left incomplete in the quarry. This is, however, uncertain, for the damage may have been caused by rain and sunshine, frost and earthquake, throughout the centuries, and it may have been external events, such as war, money shortage or the death of the man who commissioned it, which caused the work to be abandoned. The figure probably represents a Dionysos, and was not, of course, intended to be set up at the place where it was carved, but in some sanctuary nearby, perhaps even on one of the neighbouring islands, as a votive offering. The proportions of this gigantic figure are astonishing. It is about 10·50 metres (34 ft.) long, the chest is 1·70 metres (5 ft. 7 in.) broad, the upper arms measure nearly 2 metres (6 ft. 6 in.). If it were placed erect it would overtop the houses of Komiaki from the waist upwards.

It may be imagined how little the sculptors at work could see at any one time of this huge, recumbent statue on the steep slope of the hill. Even today the whole length of the statue can be photographed in profile only by joining together a series of pictures. Since the Greeks were

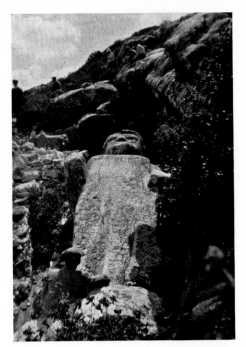
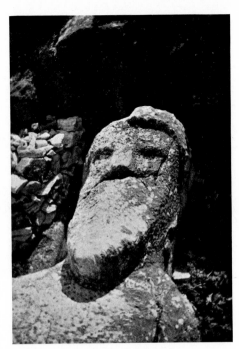

2–3. STATUE OF COLOSSUS, in the marble quarries of Naxos. Sixth century B.C.

capable, nevertheless, of mastering the technical problems involved, despite the horizontal position, they must obviously first have determined exact measurements and proportions, as for a building, and transferred these to the stone colossus. The preliminary labour in the quarry aimed in the first place at reducing the huge block of marble. If they had attempted to transport the whole original block from the quarry, the sculptors would have had to deal with double or triple the weight, and this would have been no small matter, given its size and the difficulty of the terrain.

Another quarry on Naxos, near Flerio in the province of Tragea, has yielded up the unfinished statue of a naked youth (5), in a rather more advanced stage, also still lying in the place where it was quarried. This work is also so heavy that all unnecessary transportation had to be avoided. If placed erect it would stand 5·55 metres (more than 18 ft.) high and 1·45 metres (4 ft. 9 in.) broad. The youth's left leg is slightly

7

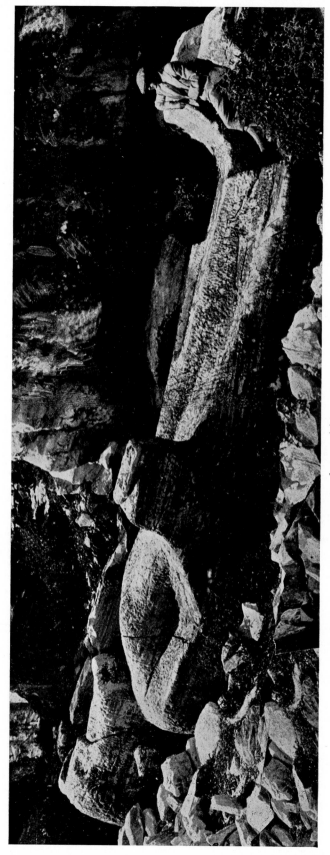

4. STATUE OF COLOSSUS, in the marble quarries of Naxos. Sixth century B.C.

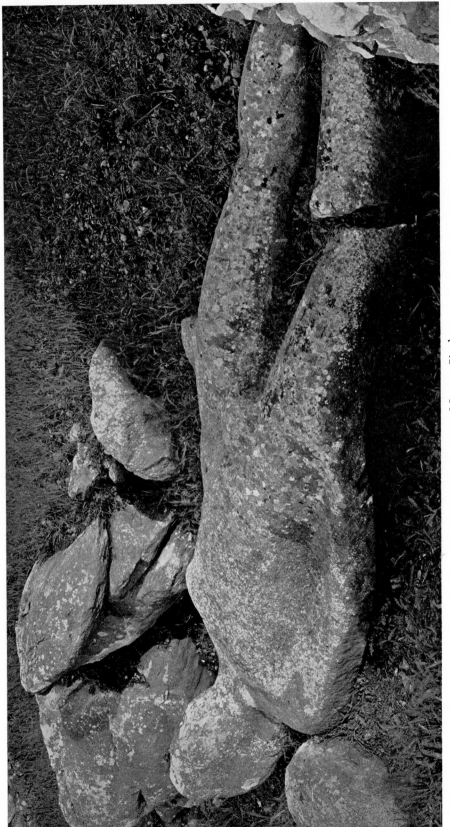

5. FIGURE OF A YOUTH, Naxos. Sixth century B.C.

forward, the arms are pressed close to the sides. There is no indication of nose, mouth or eyes; the whole figure is roughed out in broad masses only. This work, like the huge Dionysos, must have been started in the first half of the sixth century B.C.

The colossal statue of a man carrying a ram (6–8) found in the west wall of the Acropolis of Thasos had reached a much more advanced stage. The body was broken in three places, below the chest, at the knees, and above the feet. It has now been repaired and set up. It stands 3·5 metres (11 ft. 6 in.) high, that is to say, it is a third of the size of the giant on Naxos. The naked figure repeats the customary archaic position with the left leg slightly forward and 'at rest', an attitude which Greek sculptors must have observed in Egyptian statues. The right arm, the greater part of which is now missing, lay alongside the body. The left holds a young ram clutched to the breast. The hair, bound close to the head with a band, falls in eight strands, four over each shoulder onto the chest, and another eight down the back. The work was probably abandoned on account of the great cracks in the left side of the head, which extend across the chest as far as the ram's head. Neither the sculptor nor the donor would have dared to exhibit such a faulty piece in the sacred precincts of the god. The Thasos ram-bearer, probably a representation of Apollo, is certainly the earliest of the three unfinished statues. It dates from the beginning of the sixth century B.C. and is one of the oldest surviving examples of marble sculpture on this scale from the hand of a Greek sculptor.

From these three statues alone we are able to establish certain rules which remain valid in Greek sculptural technique for several centuries and only gradually cease to apply during the Hellenistic period. It is a remarkable fact and no mere chance that everything essential can be found in these three statues, although so much still remained to be done before they reached completion. The reason for this is that every Greek sculpture of the early period is, in its way, absolutely complete and whole at each stage of the work. The Greek sculptor worked at his block from all four sides and carved away one thin layer after another; and with every layer removed from the block, new forms appeared. The decisive

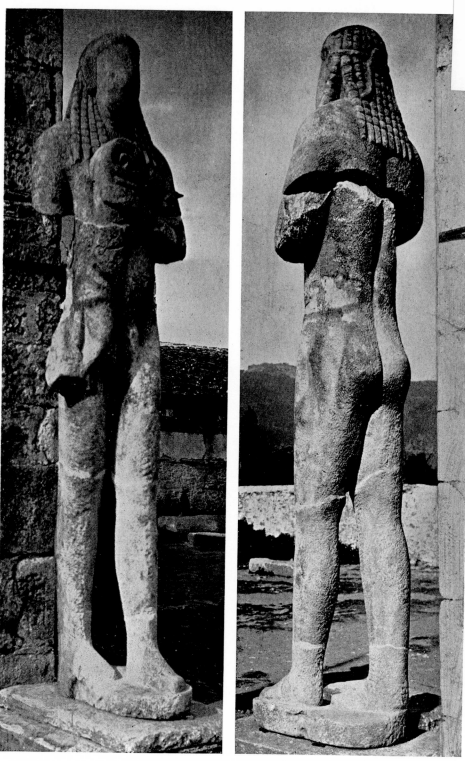

6–7. MAN WITH RAM, Thasos. Early sixth century B.C.

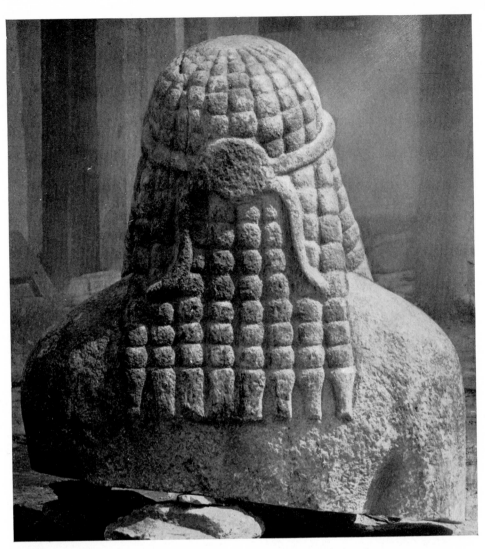

8. HEAD OF THE MAN WITH RAM, Thasos. Early sixth century B.C.

point is, however, that the Greek sculptor always removed an entire
layer right round the statue. He never worked just at a leg, an arm or a
head, but kept the whole in view, and at every stage of the work the
figure itself was a whole. No detail was allowed to obtrude during the
work, the eyes being as important as a lock of hair or a big toe. All
formed part of the whole, into which it became absorbed. Thus the
same figure which started as a rectangular block of stone was worked

12

over in its entirety by the sculptor at least a hundred times, beginning with only a few forms and becoming increasingly richer, more rounded and lifelike until it reached completion. Small wonder, then, that so much vigour emanates from a Greek sculpture, since at every layer it was re-thought by its creator, who thus charged it with added strength.

The sculptors must already have put a great deal of labour into the three colossal statues on the islands of Naxos and Thasos before they had to leave them unfinished and abandoned on the ground. The figures had already been hewn out of the stone in their main outlines, the proportions of head, body and limbs were indicated, each sculpture already possessed

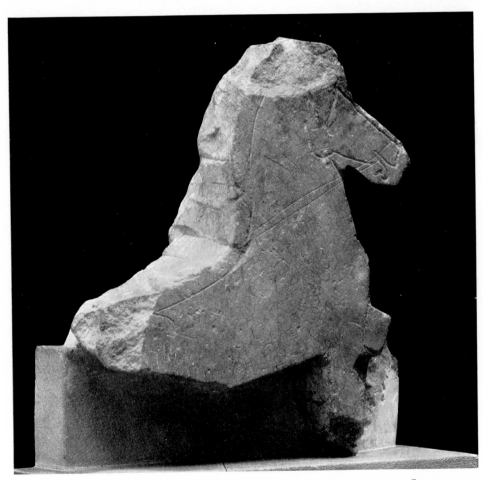

9. FRAGMENT OF A STATUETTE WITH HORSE AND RIDER, Sparta.
Sixth century B.C. London, British Museum

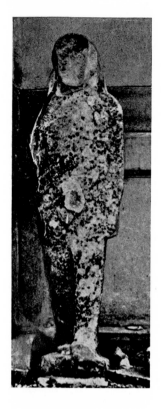

10. FIGURE OF A YOUTH, from Mount Pentelicus. Sixth century B.C.

an organic form. Three smaller, unfinished marble figures, which were abandoned almost as soon as begun, permit us to imagine what the earlier stages of the work must have been. The sanctuary of Artemis Orthia at Sparta has yielded a fragment of an unfinished marble statuette of a horse (9) which is only 20 cm. (7⅞ in.) high, 16 cm. (6¼ in.) long and 6 cm. (2⅜ in.) across. The smoothly cut surface of one side reveals an incised sketch of a horse's body, even the reins being indicated by thin lines, and the artist had just begun to chisel the horse's silhouette out of the stone. The marble had been cut exactly along the outline in front and below, but the sculptor had not quite reached the previously traced outline of the horse's head and back. The horse was originally intended to bear a small rider. The body has unfortunately broken off and all that is left is a trace of the preliminary outline of his knee on the animal's back.

The statue of a nude male figure (10) discovered near Dionyso on the northern slope of Mt. Pentelicus beside an old quarry was carved entirely

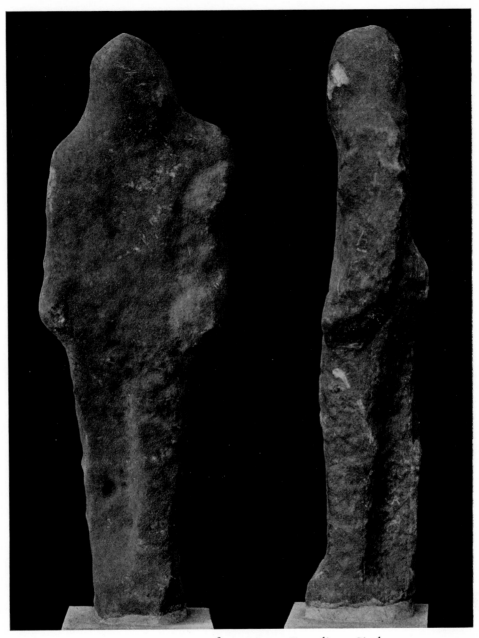

11. STATUETTE OF A YOUTH, from Mount Pentelicus. Sixth century B.C.
London, British Museum

in the rough in a similar fashion out of a block of marble 2·10 metres
(6 ft. 11 in.) high, by an Attic sculptor. He began by working on the
principal outline of the front view. The arms are held close to the body,

and although there is an indication of the left leg's being slightly thrust forward, the whole block at this early stage has an almost two-dimensional effect. Work on the side views has only just been begun, the front view having been the most important in the beginning. This work, too, was left incomplete because flaws appeared in the marble and pieces flaked off. Thus the whole face, the right shoulder and the arm broke away.

Another male statuette (11) only 48 cm. (19 in.) high, and 12 cm. (4¾ in.) wide, which was also found near Dionyso, illustrates how the side view was gradually included in these early stages of the work. This figure, too, has not got beyond the first rectangular stage, but it is already evident from the side view that the sculptor is at pains to shape the back of the figure; the front view is no longer all-important.

A life-size male figure (12–13), of which the lower legs are missing, has reached a much further stage of development. The block is now 1·02 metres (3 ft. 4 in.) high. A peasant found it in his field on Nassos, quite close to the huge Dionysos, and it is now in the National Museum at Athens. The sculptor had blocked out the figure on all four sides in broad planes meeting at right angles, and had begun to round off these main surfaces and relate them to each other as parts of a whole. At that stage he was still completely indifferent to finer details. The hair, hanging down the back of the neck, is an undifferentiated mass. The nose and eye-sockets are hinted at, but nothing more. The sculptor has not yet tied himself down to any set form. Since this torso was buried in the earth and the surface was therefore not exposed for hundreds of years to the effects of the weather, the point work can be seen in detail. The simplicity of design in this figure is matched by the simplicity of the tool used. The sculptor used only a bronze punch, applied over and over again at right angles to the block; hence we see a whole series of closely juxtaposed small dents. Obviously the Greek sculptor used a heavier punch, perhaps even a pick, in the early stages, and gradually went over to increasingly finer tools until he had finally modelled every detail according to plan.

This would not, in itself, be in any way unusual. No sculptor has ever

16

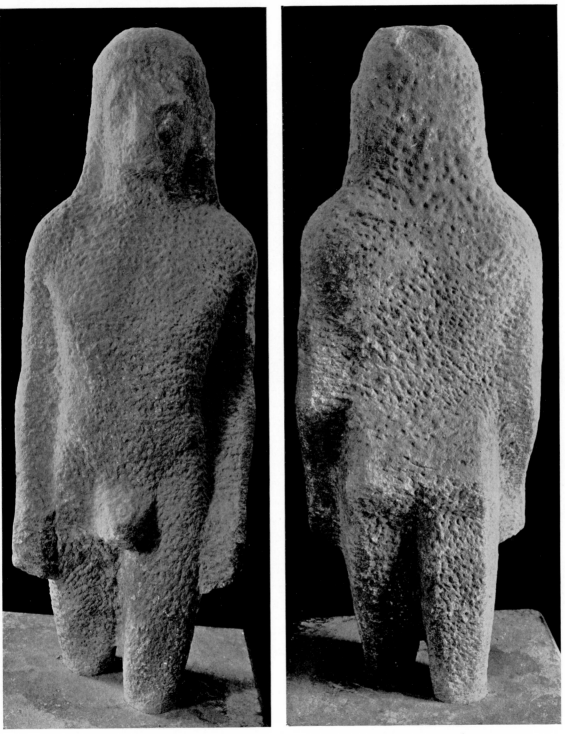

12-13. MALE TORSO, from Naxos. Sixth century B.C. Athens, National Museum

yet begun to work upon a marble sculpture with anything but a pointed tool. What is most striking in the torso is the exceptionally fine point work and, above all, the extremely regular way in which the point has been applied invariably at right angles to the surface. It is rare to see furrows resulting from the use of the tool at an oblique angle. This kind of technique is readily understood when we remember that the Greeks were not acquainted with tempered steel and were obliged to work with softer bronze punches or points, which rapidly became blunt. The fine point work on this torso could easily have been made with a fairly blunt tool. The only object was to pulverize small areas of the marble surface with the point so that they would flake off. The sculptor carried on with this striking with the point until he could smooth the surface with emery and pumice. This was a wearisome task, which required great patience and in any case did not always eliminate marks where the point had penetrated too deeply. Thus, particularly in early Greek sculpture, we often find that the surface is pitted all over, this being the result not of later damage, but merely of point work that went too deep and was not completely obliterated in the process of smoothing. Pointing often rendered the marble surface friable so that it then easily weathered away. A beautiful male torso (14), also from the island of Naxos and now in the Altes Museum, Berlin, bears exceptionally clear traces of such point-work, pitting being apparent over the entire surface of the body.

This method of treating marble constitutes one of the chief differences between Greek treatment of marble and the techniques of later epochs. All marble sculpture in exhibitions and museums of modern art has a translucent surface, white as alabaster, which the uninitiated expect to find in all marble statuary. To them, Greek sculpture does not look like marble at all, because of its opaque, granular, yellowish-grey surface, almost resembling that of ordinary limestone. The only reason for this is the different way in which the stone was treated during the process of work. If a point is used at right angles to the block, as the Greek sculptors used it, the blow fractures the fine crystalline structure, sometimes to a depth of 2 cm. ($\frac{3}{4}$ in.), and the stone thus loses its translucence and acquires

18

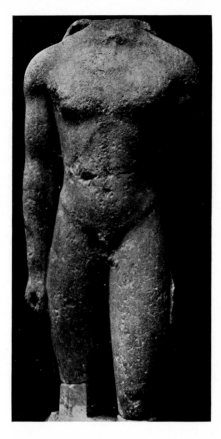

14. TORSO OF A YOUTH, from Naxos.
Sixth century B.C. Berlin, Museum

an opaque appearance. The modern sculptor avoids this so-called 'stunning' of the marble. He uses a point or pick at right angles to the stone only in the earliest stages of the work. At a later stage he strikes lighter blows because he holds the tool at a more oblique angle, and when he gets closer to the surface of his sculpture he uses a flat tool which looks like a miniature crowbar, and very carefully removes the final layers without stunning the marble. This process is followed by painstaking polishing, and the marble takes on the gleaming, translucent appearance which the layman imagines to be characteristic of this stone. To enter into an argument upon which method of treatment of the surface is more beautiful would be idle. But the use of the flat chisel would have the effect of rubbing off, as it were, the peculiar bloom of the marble surface upon which intensive point work has produced a velvety depth, lending life to almost every individual grain, to an extent seen only in Greek

19

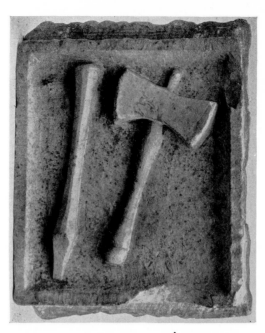

15. VOTIVE RELIEF WITH SCULPTOR'S POINT AND MALLET.
New York, Metropolitan Museum of Art

sculpture. In view of the supreme importance of the point in Greek sculpture, one might almost regard as symbolic the votive relief offered by a Greek sculptor in thanksgiving to his god, in which the only objects are his point and his mallet (15). These were his two main tools and they served him for his life's work. They deserve to be honoured by this silent tribute.

The Greeks learnt this intensive use of the point from the Egyptians, Babylonians and Assyrians, their masters in the art of sculpture, who were only able to work their very hard rocks such as granite or basalt by thus laboriously pulverizing the surface. What granite exacted from the Egyptians, however, was applied by the Greeks to their much softer marble, as they conscientiously subordinated themselves to a tradition which, in the course of centuries, attained considerable understanding of and feeling for material. We must always remember, moreover, that Greek sculpture was once coloured. It is hardly necessary to point out that colour is better suited to a matt surface, which will retain it where a smooth polish would not.

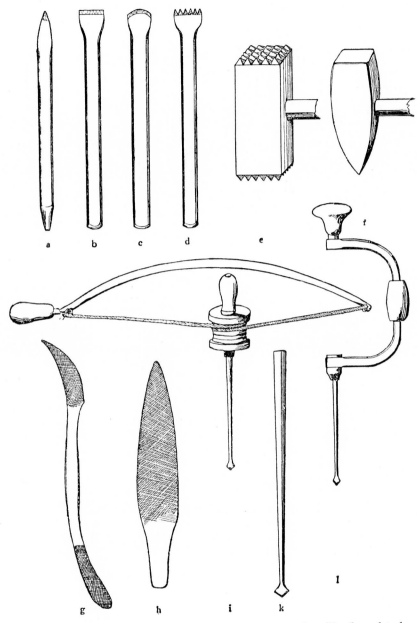

16. SCULPTOR'S TOOLS: (*a*) point or punch, (*b*) flat chisel,
(*c*) bull-nosed chisel, (*d*) claw-chisel, (*e*) doucharde, (*f*) pointed
hammer, or trimming hammer, (*g*, *h*) rasps, (*i*) running drill,
(*k*) drill, (*l*) auger

The differences between Greek point work, followed by smoothing of the surface with emery or pumice, and the extensive flat chisel work adopted by Roman and more recent sculptors in order to avoid stunning the surface, often escape us. We have become accustomed to the appearance of Greek sculptures and take it for granted that they must look different from Roman or modern works. This is regrettable and was not always the case, as we learn from a short anecdote in Stanley Casson's book, *The Technique of Early Greek Sculpture*. When in 1816 it was proposed to purchase the Parthenon sculptures, Richard Payne Knight, speaking before the Royal Commission, expressed the opinion that these sculptures had not been smoothed with a flat chisel and rasp, but had simply been polished immediately over the punch work. Since authentic Greek sculptures, such as the Laocoon, bore clear traces of having been smoothed with a flat chisel and rasp, he concluded that the figures of the Parthenon frieze could not be Greek. He considered them to be Roman works of Hadrian's time. Payne Knight's observations were, in fact, quite correct, although the conclusion he drew was mistaken. The Laocoon is about 350 years later than the sculptures of the Parthenon, and the technique is so very similar to Roman, that the smoothing of the surface is no longer typical of works dating from the classical period.

If anyone still doubts whether the process of work adopted for the Parthenon sculptures was really such as we have described, he should examine the figures from the pediments of the Temple of Zeus at Olympia (17) and of the old Temple of Apollo at Delphi; the backs have not been finished and the work may be seen in the final stages. In the middle of the back we find work done with the point such as may be observed in all unfinished Greek sculpture, and these pitted surfaces adjoin the polished front surface without any transition at the sides. On the border-line between the unfinished and the smoothed surfaces we find at most an occasional stroke with the point that went too deep and could not be entirely eliminated through rubbing with emery and pumice. The unfinished back of the torso of a bending man (18) in the National Museum at Athens also exhibits traces of punch work, which is carried over

22

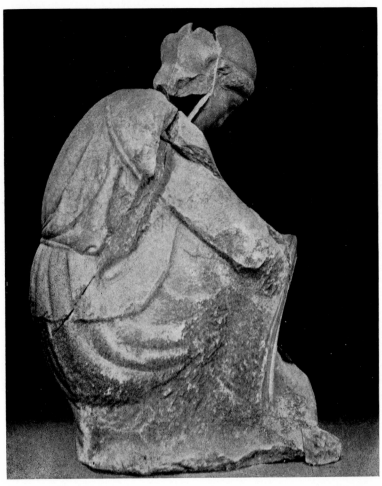

17. KNEELING HANDMAIDEN FROM THE EAST PEDIMENT
AT OLYMPIA. About 460 B.C. Olympia, Museum

without transition into the smoothed, finished front surface, no trace of the flat chisel being in evidence. All those sculptures of the Imperial period on which the back surface has been left unfinished give us an entirely different picture. The smoothing was done in consecutive and clearly distinct layers, which at the point of transition did not always completely overlap. In the middle we find the usual punch work, often rather coarsely done, on either side of which are stripes of claw chiselling, succeeded by a section of flat chiselling and finally by marks of a rasp. Every modern sculptor follows more or less the same sequence of tool work today when smoothing a surface.

23

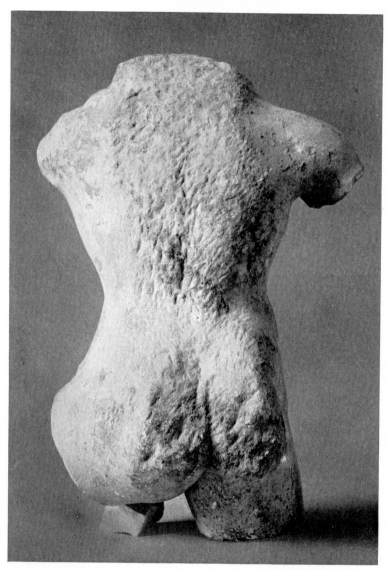

18. BACK VIEW OF A NAKED, BENDING MAN.
First half of the fifth century B.C. Athens, National Museum

The nude male torso (19) is supposedly an early Greek piece; minor details indicate that this, too, was not completely finished. No traces whatsoever of the punch are to be seen, but the whole surface has been neatly roughened with a claw chisel. To assess this piece is simple enough. It is a modern fake. The sculptor has not dared to stun the marble, having as a student been warned against doing so. But his beautifully copied

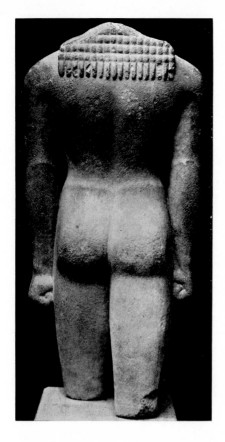

19. MALE TORSO, fake.
Private collection, England

torso had no antique look about it. In order to give it an antique surface, he therefore roughened it all over from top to bottom with a claw chisel. Only a layman could be deceived by this trick. It is surprising that even the best fakers have taken so little trouble to learn the elementary rules of ancient sculptural technique. They usually make their fakes according to the latest processes and then attempt to give the piece an antique look by fracturing the surface by artificial methods. In this they usually fail, because enough of the modern surface is always left to betray them.

The archaic head (20–21) of a nude statue of a youth dating from the middle of the 6th century B.C., now in the Munich Glyptothek, is said to have come from one of the Greek islands. It was abandoned at a very late stage. Around the head, with its long hair at back and sides, there was once a fillet, of which only the groove remains. The strands of hair behind the ear, most easily seen in the side view, were only roughed in. On the

25

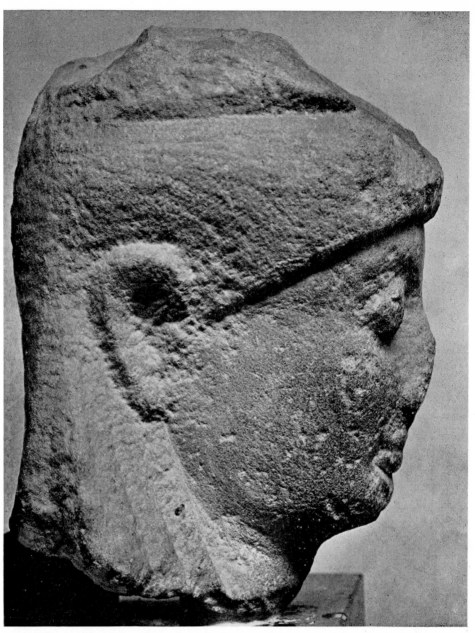

20. HEAD OF A YOUTH. Sixth century B.C. Munich, Glyptothek

left side, which is not nearly so far advanced as the right, the ear and hair form merely a flat surface. The forehead and cheeks have already been smoothed almost to a finish with emery and pumice, and as usual the

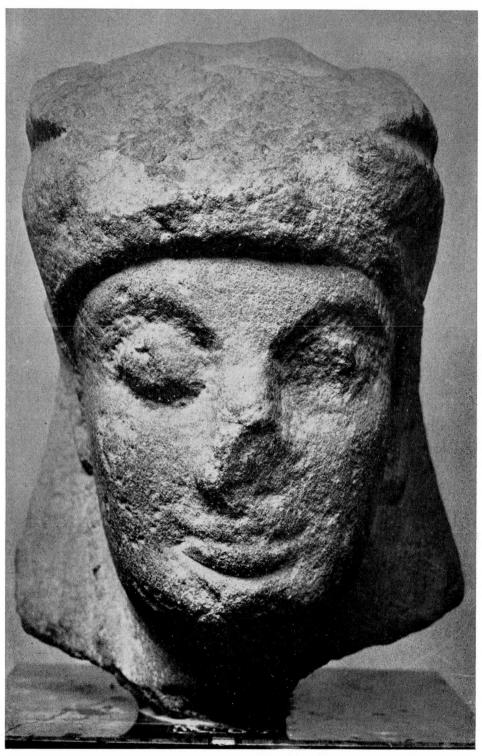

21. HEAD OF A YOUTH. Sixth century B.C. Munich, Glyptothek

smooth surfaces are pitted all over with lighter marks where strokes of the point had penetrated too deep. The very protruding eyes have not yet been modelled in detail and there is no sign of the eyelids. Traces of a finer point are discernible on the right eye and ear, and beside them the marks of another tool. The hair on the right hand side of the head, and the socket of the left eye exhibit four or five grooves running parallel to one another, which indicate the use of a claw chisel. This tool is, in fact, no more than a multiple fine point, and is used more or less in the same way. The early Greek sculptor used it almost exclusively for rapid strokes almost at right angles to his figure. The work with the point is usually followed by work with a claw chisel in order to eliminate and smooth over uneven patches. It is often used to help the stonemason's eye distinguish clearly between the various planes that have first been evenly worked all over with the point — for instance between hair and facial skin, or between clothing and naked parts of the body.

Early Greek sculptors occasionally used a flat chisel — not, however, in order to smooth the surface, but only so as to lend particular emphasis to certain parts by a sharp edge, bringing them into greater relief against a more indistinct background. Eyelids, for instance, can be sharply differentiated from the eyeball by means of a flat chisel, and a clearer outline given to lips, but this tool was used above all to accent the delicacy of strands of hair, or to give the rich decorative zig-zag folds of a robe the look of chiselled ornamentation. The same is true of inscriptions; the flat chisel is the only tool capable of cutting the clear, sharp angles and edges of individual letters in marble. Much can be learnt about the use of the flat chisel from the right profile, largely concealed from view, of the Apollo on the West pediment at Olympia (22). This shows clearly the extent to which the sculptor worked with a point. But the individual strands of hair at the sides have been cut with the chisel in harsh firm lines, and there is no transition between them and the still rough state of the back of the head.

The sculptor also uses a bull-nosed chisel, which makes shallow, rounded grooves in the stone when the rounded cutting edge is applied obliquely.

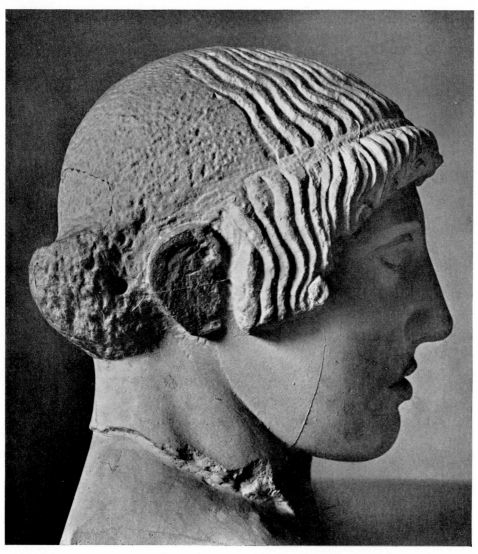

22. HEAD OF APOLLO, from the west pediment at Olympia. About 460 B.C. Olympia, Museum

Crinkly hair or the regular, fine folds in drapery of female statues were sometimes worked with this tool. But the sculptor would never work upon naked parts of the body with this form of chisel; these he modelled exclusively with the point and the claw-chisel.

Greek sculpture in the early classical period brings no change in the use of these tools. The small, unfinished head of a youth from the Delion

on Paros makes this clear (23–24). It is only 15 cm. (6 in.) high and is almost finished. The whole surface was worked with the point, and the smoothing of the face had already been begun. Only along the fillet, the edge of the hair and at eyes and mouth did the sculptor make a few sharp cuts with the flat chisel. The face of the small finished head from the Asklepieion (25–26), with its somewhat granular surface, also bears clear traces of the point, whereas the delicately carved curls and locks of hair, the eyelids and the mouth have been worked with a flat chisel sharp as a knife.

Sculptors also used the drill, which they probably took over from carpenters and joiners. It is the simplest of tools, in point of fact nothing more than a sharp, flat chisel, terminating in a short point; it is whirled between the palms of the hands and bores holes in the stone. In order to put more power behind it, the tool is usually given the cranked form of a joiner's drill with a large round knob or grip. The sculptor can then brace it against his chest and revolve it with his hand. Modern sculptors call this tool an auger. If several holes are bored in sections where the work must be carried to some depth in the stone, the advantage is obvious, for then the point can be applied much further in and larger fragments broken away than when the whole process is carried out laboriously with the point alone. The long, narrow grooves of folds, especially, can be more easily worked with a drill than with any other tool, because holes may be drilled close together and the small sections of stone remaining between them can then be removed with the point. A drill of this kind has bored to such a depth in some parts of the Olympia sculptures that it has left its traces on the surface of the finished work.

In the second half of the fifth century B.C. some Greek sculptures already show evidence of the use of the running drill. In this form of tool, the drill itself is fixed to a wooden reel, coarsely wormed on the outside. The drill and reel are so set into a strong handle that they are able to revolve. A length of cord turned once around the reel is stretched across a metal bow with a handle at one end which the sculptor holds in his right hand. A sweeping movement sets reel and drill spinning fast, these being

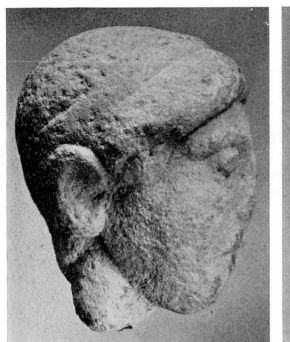 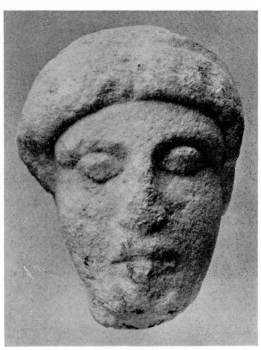

23–24. HEAD OF A YOUTH, from the Delion on Paros. About 480 B.C. Paros, Museum

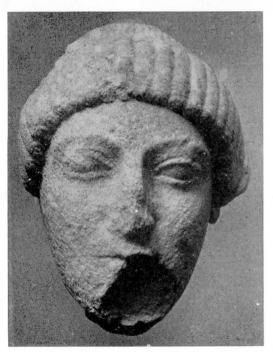 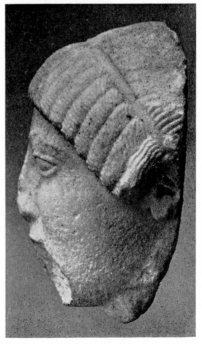

25–26. HEAD OF A YOUTH, from the Asklepieion, Paros. About 480 B.C.
Paros, Museum

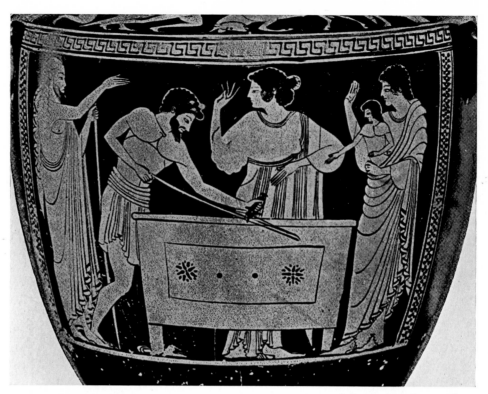

27. CARPENTER USING A RUNNING DRILL, on a red-figured hydria with
the myth of Danaë. About 500 B.C. Boston, Museum of Fine Arts

guided with the left hand by the handle above the revolving reel. A
worker using this tool can be seen upon a gem in the British Museum
(61). Although he is not a sculptor but probably a gem-cutter, the gem
itself gives an excellent idea of the way in which the tool was handled.
A joiner using the same tool upon the lid of a wooden box can be seen
on a vase in Boston (27), which represents the myth of Danaë. A drill of
this kind enables the sculptor to penetrate better than with any point into
deep folds and makes under-cutting possible. The fussy, complex
draperies on later Greek sculptures could not have been cut otherwise.
The use of the drill was continually extended; it was adopted not only
for undercutting drapery, but to divide up strands of hair, to cut beneath
eyelids, and in reliefs it was sometimes used like a crayon, deep channels
being made, so as to accent the outlines.

32

One further tool remains to be mentioned, the rasp; it is similar to a file, and leaves fine, irregular scratches on the surface. On early Greek sculpture one finds it often used in the places the sculptor was preparing for an application of colour. Later it was used more generally, and became the tool for smoothing the surface, instead of emery and pumice. Work with the rasp is particularly in evidence on the back of a small male torso (41) which was found at the foot of the Acropolis in Athens near the theatre of Herodes, and is now in the Berlin museum.

ALL the unfinished sculptures dealt with so far date from the early Greek period. They were all erect, rigid figures whose manner of construction is manifest. In every case the main axes of the limbs lay parallel to one side of the original rectangular block. The sculptor could first rough out his figures, front, back and sides, on the marble, and then carve them layer by layer out of the matrix. Two thousand years earlier, Egyptian sculptors had worked in the same fashion and from them the Greeks learnt the main principles of stone carving. But at the beginning of the fifth century B.C. a radical change occurred. With the help of newly discovered perspective, the Greek sculptor was no longer confined to the rigid, front-facing position, but was able to represent any figure in any pose. With this brilliant discovery, something quite new had come into the world; the Greeks laid the foundations for the great edifice of western art.

The sculptors must have encountered great difficulties in carrying through this new development, for they had to incorporate innumerable freshly observed facts into their conception, and then into the creation, of their sculptures. When an early Greek sculptor began his work from the four main aspects of the block and roughed out the sculpture in broad planes, every stroke of the point was confined to one or the other of those planes, and when he began to cut the intermediate facets between them, each of these was again a well-defined plane. Only gradually did he begin to work upon curves and more indefinite transitions, which could also be easily distinguished because they were circumscribed. But the difficulties increased enormously when the sculptor was no longer content with the four main aspects and began to combine in his figure many others beside the main frontal view. The multiplicity of aspects deprived him of fixed points of reference and of the planes upon which he had built up his figures. For now he must think in terms of curves rather than in terms of flat planes. As he worked, his sculpture came to represent the sum of a great diversity of contours. Conceptions of planes, but now of planes abutting at a great many different angles, will still have guided him, but his real point of reference must always lie in one of the many

contour lines, so that every stroke of the point had to be seen in so far as possible within the context of a complete contour.

For this reason an artist carving figures for a pediment found that it was a help rather than added work to rough out in broad lines the reverse sides, although no one was to see them. There is little difference, for example, between the work done on the front and that on the back of the kneeling girl (17) from the east pediment at Olympia. The sculptor merely omitted the final, very laborious task of smoothing the surface after the point work. The artistic practice of the period, as I have already pointed out, rendered such a process necessary in order to give the figures artistic balance from the side and oblique view. Little more than summary treatment of the back was required to realize the sculptor's idea of a sculpture in the round, and the execution of further detail would have contributed little or nothing.

Whereas the Greek sculptor of the archaic period, working with the point, carried all four aspects of his work through to a certain degree of finish before proceeding to the next layer, the sculptor of the classical period had to work over the whole figure with the point before beginning to remove another layer. Later, some decades after the completion of the Olympia sculptures, the backs of the figures on the pediment of the Parthenon were not only roughed out, but even completely finished, though not in such detail as the front, in accordance with the extensive formal requirements which had by then become the rule. The relations of mass in the figures on the pediment could not have been worked out to so fine a tolerance, had the work on the back and parts of the side views not been executed. These requirements were purely technical ones; only thus and in no other way could the sculptures have been developed out of the stone.

The seeds of this art had already lain dormant in archaic sculpture. When, as early as the archaic period, Greek artists set up free-standing stone statues which were independent of all supporting structure or architectonic relation — as opposed to the entirely different conception of the Egyptians — they had taken the first and most important step

35

towards a sculpture which took all aspects into account and was to rely principally upon the contour.

In the case of figures in vigorous movement, it behoved the sculptor not to lose his way within the block of marble. He first had to form a model in wax or clay; in order to make this more durable a stucco or plaster cast of it was then made, and only at this stage could the work in stone begin. A picture on an Attic vase shows us a clay model of this kind. The goddess Athena herself is seen modelling a horse (28). Her accoutrements are informal, as befits an artist at work, but in order to be recognized as a goddess she has kept on her helmet with its tall crest. She has laid her other weapons aside and draped her cloak around her like a kilt, in order to leave her hands free. She is seen modelling the horse out of clay. A big lump of this material lies at her feet and she has some more ready in her left hand, while with her right she is engaged upon modelling the horse's muzzle. The work is well advanced, although the lower part of one hind leg is still missing. The clay figure stands upon a low pedestal, which must be assumed to be of wood. Some carpenter's and joiner's tools, including a saw and a drill, can be seen on the left, hanging on the workshop wall. In order to make the modelling clay seem more realistic, the artist has simply painted the horse and the two lumps of clay with slip.

It has been suggested that the picture shows the goddess Athena making a model of the Trojan horse. This explanation seems rather far-fetched; the painter was probably not thinking of the myth at all, but only wished to represent Athena as patroness of artists and craftsmen. Here, herself a sculptress, the goddess is modelling a horse such as those of bronze and marble so often dedicated to her on the Acropolis at Athens.

How were the models produced which Greek sculptors used for their larger works in marble? At first a small preliminary model was formed in wax or clay, but this only served to render the construction of a larger one possible. A life-size head in damp clay weighs more than half a hundredweight. Larger models therefore require a strong metal armature, which often has to include even fingers, in order to support the immense weight of clay. Such armatures cannot be altered during the course of

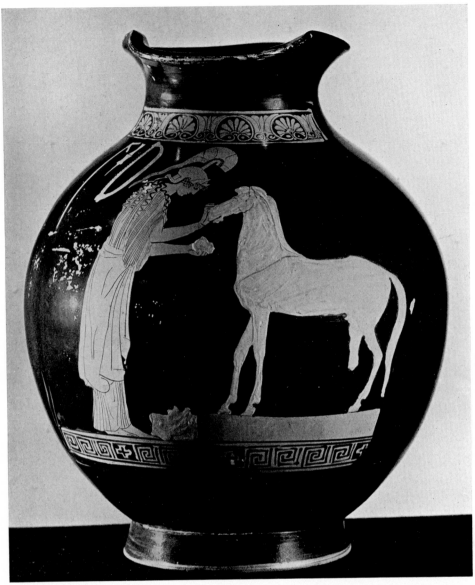

28. ATHENA MODELLING A HORSE, on a red-figured jug from Athens.
After 470 B.C. Berlin, Antiquarium

work, and cannot even be bent; they have to be worked out in advance
down to the smallest detail on the basis of the preliminary model. This is
an extraordinarily difficult task and presupposes a great deal of technical
experience. Even when the larger models have been built up, the sculptor
can do nothing with them, because their great weight and fragility make

37

them completely immovable. But he must be able to shift them about while working, and to place them where he needs them, especially in the light, so that the stonecutters can constantly refer to the model. Hence plaster or stucco moulds have to be taken of sections of the larger models, and these negative moulds provide a further opportunity for work on the formal details of all the figures. Casts from these moulds supply the sculptor with the final models, from which the work in marble can be begun. These models are cast hollow, like terracotta figures; they are solid enough to be moved about the workshop and, if required, can be taken apart. This latter point is extremely important. Imagine a sculptor working high up in his studio upon the head of Zeus for the east pediment at Olympia. His model would not be much use to him if it were standing upon a table below him, and all he could obtain were a bird's-eye view from a distance. He can work upon the head only when the model cast is set up beside him upon a high scaffolding where he can reach it at any time and shift it into the position he needs. Even so, the sculptor's difficulties are considerable because he is usually so close to his work that, especially where larger figures are concerned, he is unable to obtain a clear view of the whole. How is he to achieve the proper proportions if he has no large model or full-size details to work from? He cannot be constantly climbing up and down the high scaffolding.

Pediment groups for a temple cannot be improvised from small pre-liminary models alone. They demand very accurate work, where every millimetre counts. If the groups are to stand in proper relation to one another within the pediment — and here the intervals between the individual figures are as important as the figures themselves — and if the different overlapping parts are to form an harmonious whole for the spectator below, the sculptor must be able to bring the models themselves to the pediment and test out their effect on the spot.

The work in negative moulds mentioned above has been found by a number of modern sculptors studying Greek sculpture to have been the process used in antiquity, and their use is further confirmed by the fact

that many surviving Greek terracotta moulds are quite evidently not only casts of clay or wax models, but have been extensively reworked by the artist. The extreme refinement and rounded fullness of forms, which fit cleanly together without leaving any gaps, could hardly have been attained by working on the soft model, where the slightest pressure of a finger would leave a depression. It could only be achieved by the use of a negative plaster cast, since the firmness of the material permits the elimination of all irregularities in the mould, with the result that no gaps remain in the cast model.

It is particularly in the case of larger models that work in negative piece moulds is significant. It is impossible, even in the best studio, to ensure that every part of a large clay model, which is virtually immovable on account of its weight, will stand in the light necessary for work on clay. But in the form of piece moulds, parts of the model can be moved without difficulty into a good light, where they can then be finished off.

It must strike everyone who examines the little moulds from Tarentum, and the plaster casts made from them (29–32), that the moulds are not easily recognizable as moulds at first glance. The illusion that the figures are being seen in relief, though lighted from a direction opposite to that from which the casts are lighted, constantly recurs. And this is the case not only with photographs, but also with the originals. It is therefore understandable that, after some practice, a sculptor would be able to work with these negative moulds confidently and happily. This must be particularly true of Greek artists who, as cutters of gems and stamps, were masters of the art of working in intaglio. The sculptor has the added advantage of working in a compact and firm material which does not smear and sag like soft clay. This is evident from the negative mould of the naked boy, for instance, where the rounded portions appear much fuller and more organic than on the cast, which seems almost flat by comparison. But since the artist can portray in his model only that which he clearly perceives, his very endeavour to perfect the forms will naturally lead him to work in intaglio.

When a modern sculptor is faced with the problem of translating a

39

29. CLAY MOULD OF AN ENTHRONED GODDESS, from Tarentum.
Fifth century B.C. Berlin, Antiquarium

larger model into marble or stone, he can use a machine which will do the
work of pointing for him. But he can also, with the help of three callipers,
mark the position of his model point by point on the stone by taking
exact measurements. This modern system of translating a model into

40

30. ENTHRONED GODDESS. Cast of the mould (29)

stone by means of measuring is based upon the geometric principle that, since three points always lie in one plane, a fourth point in space can be accurately determined by taking the three as points of departure. The sculptor first of all decides upon three main points on his model and

41

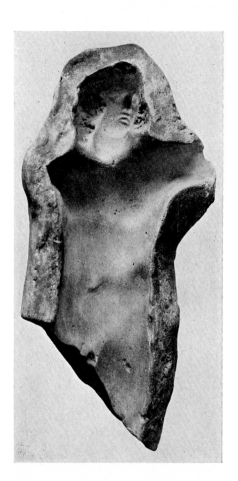

corresponding ones on the stone from which his figure is to be cut. In the case of a simple, standing figure, he usually places one point on the head and the two others on the right and left sides of the front of the plinth. From these three main points any other point on the front of the model can be measured with callipers and ascertained on the stone accordingly. The back and side views are marked out in similar fashion, first on the model and then on the stone, and these main points then serve to establish further auxiliary points. When engaged upon a portrait head a sculptor may place as many as three or four hundred points — in the case of a full-length statue infinitely more — so that the distance between one point of reference and the next is often no more than a few millimetres. Mechanical and unimaginative work, in the truest sense of the word, can

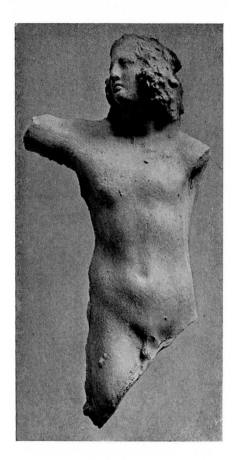

32. CAST of No. 31

thus be produced. This task of measuring and drilling, which often goes on for weeks or months, has nothing to do with art. Until the very end the stone looks unpleasantly like a sponge, for the highest projections on the model are point holes in the marble. An unfinished work of this nature gives no hint of the future forms, whereas in free sculpture the work of art may be recognized in its broad lines from the very first, and almost every successive stroke of the point is in itself creative and demands the artist's full attention.

We need not say more about modern methods of measuring, since we possess no ancient sculptures which offer any proof that they were worked in accordance with the modern pointing system with callipers. We find occasional measuring points on both finished and unfinished ancient

43

sculptures, but there are never very many of them, because the measuring systems adopted for translating a model into stone were extremely primitive, even in the Roman imperial period. They are still in use today, but rarely for stone, although they may be used to translate a small preliminary model on to the full-scale stone. In this case the sculptor attaches plummets to both models at certain projecting places which he has selected previously, then, on the smaller model, measures horizontally the distance between the point to be transferred and one of the plumb-lines, upon which he takes a vertical measurement to the point at which it is affixed. He then converts these two measurements to the scale of the larger model, to which he transfers the vertical and horizontal measurements. This is a simple means of establishing measuring points, though not, of course, a very accurate one, since the plumb-line may easily move during the operation.

Ancient sculptors were also familiar with this method of measuring by plumb-line. An early Greek gem (33), now in the Metropolitan Museum, New York, represents a naked man seated before a Herm. In his right hand there is a small stick and a plumb-line, which he holds up in front of the Herm, while his left hand grasps the line lower down, perhaps to steady it. This picture certainly represents a sculptor at work in front of a model in some pliable material perhaps intended for a bronze cast, as one might expect from the modelling tool in his right hand. If the gem engraver had intended to show him at work upon stone, he would have given him a punch and mallet to hold. A later representation on a cornelian in the Gotha Collection (35) is even clearer. On the left there is a naked man, stooping somewhat; he too holds a little stick and a plumb-line in his right hand and grasps the line lower down with his left. Another plumb-line hangs over his shoulder. A younger figure kneels on a kind of column in front of him; this is certainly meant to represent a clay model on the modelling block. It may be supposed that the archaic sculptor, who certainly did not yet make use of models for stone sculpture, used the plumb-line mainly to ensure that the construction of his work was strictly symmetrical. When progress in stone sculpture

44

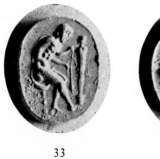

33 34

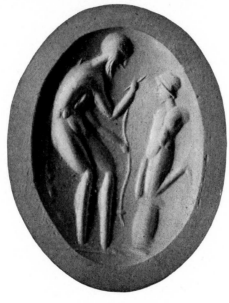

35

33–35. IMPRESSIONS OF ENGRAVED GEMS

33. SCULPTOR USING A PLUMB LINE BEFORE A HERM.
New York, Metropolitan Museum of Art

34. SCULPTOR MODELLING A BUST. New York,
Metropolitan Museum of Art

35. SCULPTOR WITH PLUMB LINE BEFORE HIS MODEL.
Collection at Gotha

45

necessitated a preliminary model, the simple plumb-lines had to be supplemented by equally simple point measurements. Every sculptor takes measurements constantly while working, at first by eye, then using two fingers, and finally with a plumb-line or a piece of string. This is a natural method familiar to any builder, joiner or shipwright. Now, since the sculptor on the more recent gem holds one plumb-line in his right hand and has another hanging down over his back, this might be an indication that the model before him was not intended for a bronze cast, but was to be translated into stone. He would use the second plumb-line for that purpose.

An unfinished statue of a youth, found upon the island of Rheneia (36), near the island of Delos, gives us a particularly lively idea of the way in which a Greek sculptor in the first century B.C. translated his model into stone by means of measuring. It was made more than 400 years later than the unfinished archaic statues on Naxos, Paros, Thasos and in Attica. The extent of the difference is immediately apparent. During the intervening centuries the artist's concept of form has undergone a change, and with it his whole fashion of setting about his work. Firstly, different stages of work can be seen in juxtaposition on this statue — every possible transition, from the finest claw-chiselling to the coarsest point work. For this reason, the figure fails to give the impression of being an harmonious whole. Archaic pieces, even when equally unfinished, are by comparison much more organic and unified. Moreover, this statue has not been wholly removed from the matrix, but only the front view has been elaborated; the back is still embedded in the rectangular block, although the sculptor certainly intended to carve a figure in the round. Hence, as compared with the Olympia statues, this represents a reverse process. For on the pediments at Olympia the effect intended by the sculptor was of a relief, yet he gave his individual figures the full three-dimensional form as far as he was able, at least during work, so that he could himself better understand his forms in their interrelatedness. The sculptor at Rheneia, on the contrary, began with relief and ended with freestanding sculpture, as did Michelangelo with the slaves for the tomb of Pope Julius.

46

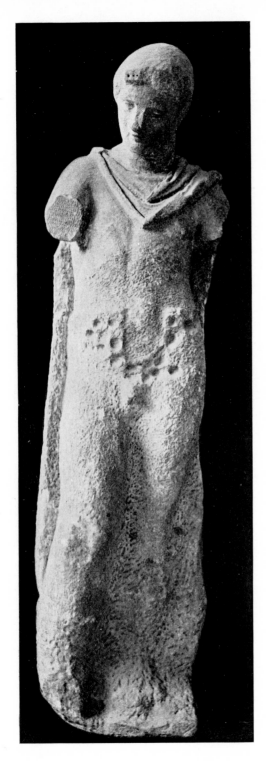

36. STATUE OF A YOUTH, from the
Island of Rheneia. First century B.C.
Athens, National Museum

Thus, to determine the depths to which he would have to penetrate, and which would be difficult to estimate from the sides in the early stages of work, the sculptor needed a system of measurement involving a series of measuring holes which he transferred from his model.

Above the forehead of the youth from Rheneia is a square block of stone about the size of a fist, which was to be removed at a later stage. On this knob there are three drill holes which correspond to two others on the lower part of the statue. The first lies within a square depression between the feet, the second on the outer side of the left foot, and there was probably a third, which has disappeared along with the front of the right foot. On the abdomen, along the border between the second and third areas of point work, there are sixteen circular depressions, about 3 cm. across and 2 cm. deep, which were hollowed out with a bull-nosed chisel. These peculiar marks are easily explained. The sculptor stretched cords between each of the holes in the boss above the forehead and those at the base of the statue; he would have already done the same in the case of his plaster model. Now, as he worked, he took vertical measurements, first on the model, then on the stone block, afterwards measuring his points horizontally from the lines to the bottom of the chisel holes on the figure's abdomen and left hip. This method constitutes another advance beyond the simple plumb-line shown on the gem, in as much as the sculptor was now using, not one plumb-line, but three different cords which, instead of hanging free, were affixed to the base of the statue. Clearly he could take far more accurate measurements from these taut lines than from a plumb-line, which can so easily be disturbed.

Now it may be supposed that a sculptor would attach plumb-lines to his model and to correspondingly prominent parts of his stone statue, thus taking points of reference lower down on the work, simply in order to see how much further in he must penetrate. Measurements of this kind would be of great assistance, even if he did not mark them by means of holes, as in the case of the Rheneia statue.

This, in fact, is what happened. Several heads from the pediments and metopes on the Temple of Zeus at Olympia still preserve above the

48

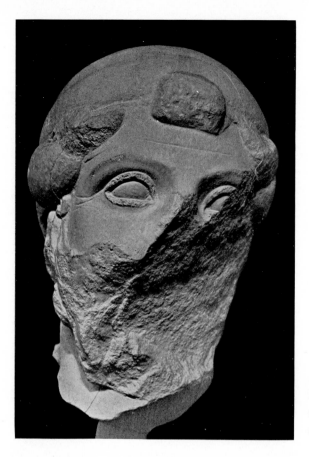

37. HEAD OF A BEARDED
MAN, from the east pediment
at Olympia. About 460 B.C.
Olympia, Museum

forehead the bosses, or their remains, for plumb-lines. This system of
measurement must accordingly have been in use by the first half of the
fifth century B.C. The bearded seer seated upon the ground in the east
pediment at Olympia (37) still has a large lump above the forehead.
Perhaps it was never removed because it was later mistaken for part of
the hair arrangement. The forehead of a kneeling Lapith strangling a
centaur, on the west pediment (38), has a rough indentation among the
locks of hair which undoubtedly represents the remains of an inade-
quately removed boss. No better place for it could have been chosen,
since it enabled the sculptor to take point measurements just where there
were a number of difficult and irregular forms, and where, moreover,
two figures cut across one another. The sculptor also appears to have
marked out fixed positions for plumb-lines in the Olympia metopes. The

49

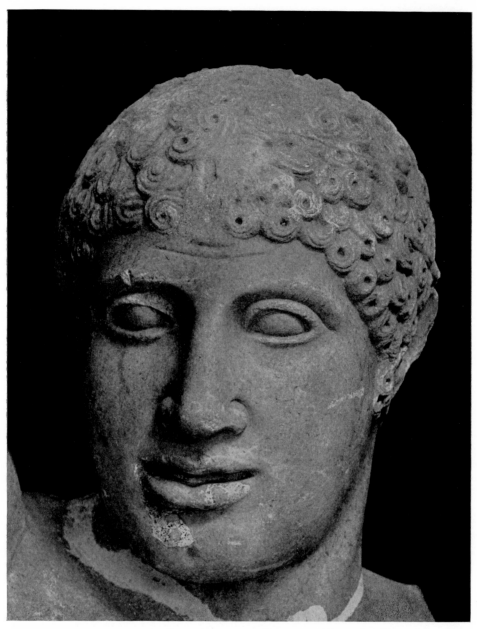

38. HEAD OF A LAPITH, from the west pediment at Olympia. About 460 B.C.
Olympia, Museum

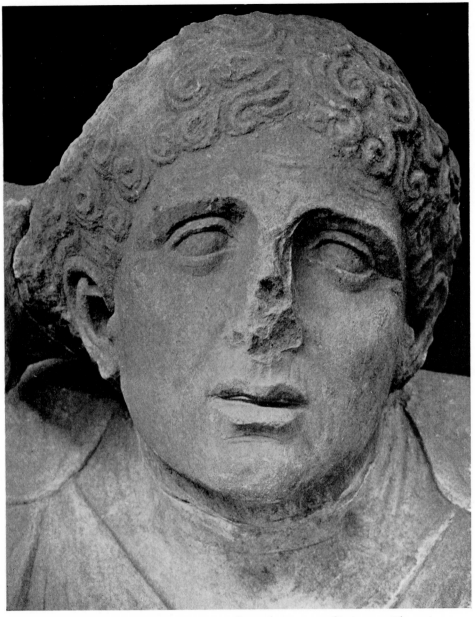

39. HEAD OF AN OLD WOMAN, from the west pediment at Olympia.
Copy, Roman imperial period. Olympia, Museum

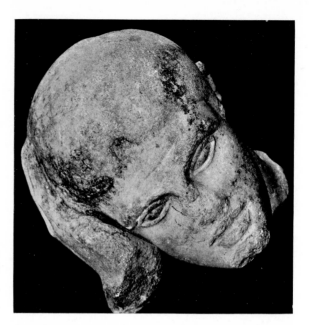

40. HEAD OF HERAKLES,
from the lion metope at
Olympia. About 460 B.C.
Olympia, Museum

heads of Herakles on the lion and Stymphalid metopes (40) exhibit a long groove in the mass of hair above the forehead; it was just wide enough for the sculptor to be able to press the cord of his plumb-line into it with his thumb. Here, too, he took account of the subsequent painting, which would hide the small incision from the eyes of a beholder standing far below in front of the temple. But these fixed points could serve the sculptor for purposes other than plumb-lines. He will have taken many other measurements from them with the help of his plumb-line. Great precision was not his main aim because at this time he was still developing the figures freely from the stone.

Measuring by plumb-line evolved still further in the Roman period. A series of small unfinished figures found in Athens at the foot of the Acropolis all bear the same arrangement of points. Each piece has pairs of measuring holes, one above the other; they may be seen, for example, on a male torso only 35 cm. (13¾ in.) high, which is in the Berlin Museum (41). The front is somewhat worn away, but on the back every stroke of the rasp can still be identified. Measuring points have been preserved, two on the chest, two on the back, on the right glutaeus and on the left thigh.

52

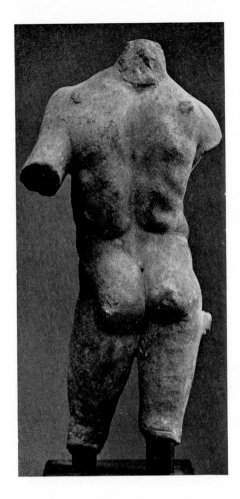

41. MALE TORSO, from Athens.
First century A.D. Berlin, Museum

These must also have been calculated by means of the plumb-line, but not by the same method as in the Rheneia statue, where the sculptor attached his line to a knob on the head, working out his point measurements from this. The accompanying diagram will make it easier to understand the method followed (42). A square frame divided into a scale marked 1 to 11 is suspended above the model. The frame is grooved at each number, and the sculptor can therefore move the plumb-line, which is fastened to the centre of the frame, from one number to another, and drop it as required in order to calculate his points. He must obviously suspend a similar frame and plumb-line over the block of stone from which the statue is to be carved.

53

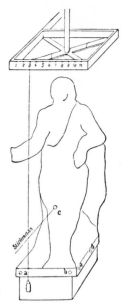

42. Diagram of measuring method with plumb-line

A frame of this kind, or perhaps just a board to which he could attach his plumb-lines, must have been used by the sculptor of the small, unfinished torso to help him establish his points. Where several of these points appear vertically one above the other, the object was the sensible one of saving time; he sought to place as many points as possible with the same plumb-line.

The main purpose of this measuring and plumbing was to enable the sculptor to translate his model into stone as accurately as possible, particularly when he was working on complex figures. The Olympia sculptures, of course, still resembled all other archaic work in that the sculptor removed the statue layer by layer out of the matrix with the point. In doing so, he used the plumb-line as a guide. He could thus check the angle of one plane against another, and the depth to which he must penetrate at certain key points.

By Roman times, however, these measuring techniques had reached such a degree of refinement that the old, laborious, but artistically valuable process was completely abandoned. As on the small Athenian torso, the sculptor transferred several important measuring points from his model

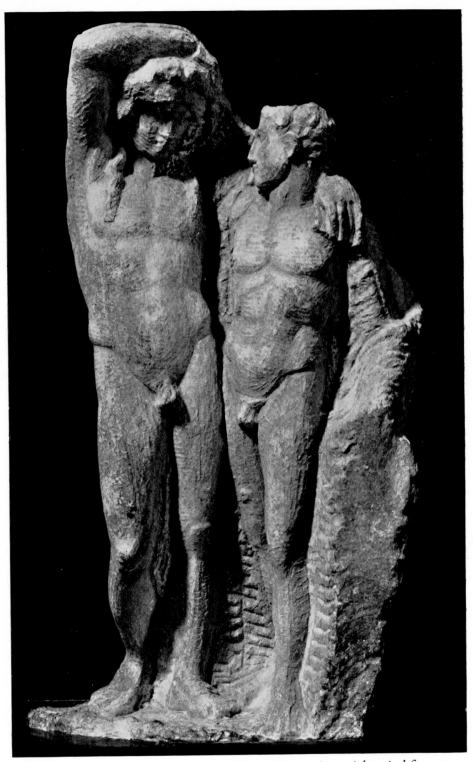

43. DIONYSOS WITH SATYR. Copy, Roman imperial period from
a fourth-century B.C. original. Athens, National Museum

to the stone, but then, instead of developing his figure out of the matrix slowly, layer by layer, he would use a heavy punch or pick to break away the first fifty layers in order to reach his measuring points. His true artistic activity began only at this stage, and consisted in nothing more than the removal of one final thin layer from his figure. This was usually done not with the point but with the flat chisel. Since his points provided sure guidance, he could concentrate upon clearly defined sections without being obliged to bear the whole figure in mind. The work thus required much less mental tension, and at the same time remained no less accurate in the purely technical sense, but it lost enormously in artistic vigour.

An unfinished group in the Athens National Museum, which represents the young Dionysos accompanied by a youthful satyr (43), shows what were the results of this new procedure. The piece is only 71 cm. (28 in.) high; it was found in Athens below the Acropolis beside the wall surrounding the Olympieion. The subject was extremely popular during the Roman imperial period, and is often found as a freestanding group, but also in the form of ornamental supports. The god holds his right arm bent over his head, his left is thrown across the shoulders of his companion, who is gazing up at him. Only the backs and the satyr's arms are still embedded in the marble from which the front of the statue has been carved, three quarters of it being free of the block. The forms of the two figures have been sharply carved into the remaining matrix. The surfaces of the bodies, with regular traces of the flat chisel, are clearly differentiated from the parts of the stone that have been left rough. Various measuring points have been carefully placed — for example in Dionysos' hair, on his shin, and above both knees, as also above the knees of the satyr and on the right side of the latter's breast. Everything is extremely neat and precise. One has the impression that this sculptor is incapable of making a mistake. But the whole remains cold and academic. The artist would almost seem a somewhat anxious copyist of his own model.

THE crucial difference between original Greek sculptures of the fifth century B.C. and the frequently arid classical copies of the Roman imperial period is best brought out by comparing several incomplete pieces.

The museum on the island of Aegina possesses a torso (44 and 46) which was carved at the beginning of the fifth century B.C. and is therefore contemporary with the warriors from the pediments of the Temple of Aphaia, which are now in the Glyptothek in Munich. This, too, may have been planned originally as a pediment figure. As in archaic sculpture, only the point was used for this work, achieving a lively alternation of most varying forms which, like waves on a sheet of water, yet make up an indivisible whole. On the back, the spine and the contour of the shoulder blade are indicated almost as in a painting by the somewhat stronger shadows resulting from vigorous point work. With these the sculptor has, as it were, sketched in the work he was about to do without at this stage tying himself down to any definite forms. While working, this sculptor does not think in terms of back or front, upper or lower parts; he is aware only of the body in the round, organic and entire.

Now let us compare a male torso, almost identical in theme, which dates from the Roman imperial period (45 and 47). This piece, carved by a copyist, shows a front and back at different stages of work — a clear indication that each was worked separately. Again, the work shows a medley of the most varied tool marks. There is evidence of considerably more work with the smooth flat chisel than with the point. Finally, the individual forms on the breast and other parts of the body are sharply demarcated and distinct one from the other, so that the sculptor was denied all freedom of movement at later stages of the work. He conceived the sculpture as a series of adjacent planes. Unlike the Greek of the fifth century, he no longer saw the body in the round, as an indivisible entity. This is what is crucial, and not the use of this or that tool. But it is obvious that a sculptor who is thinking in terms of planes will use a flat chisel whenever possible.

A head and torso in the Acropolis Museum at Athens (48) is an especially instructive example of the technique of Roman copies. It was intended to

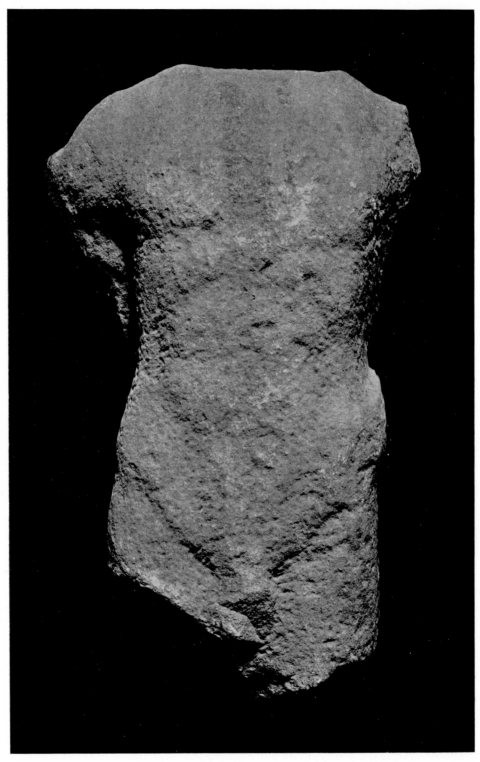

44. MALE TORSO. About 480 B.C. Museum on Aegina

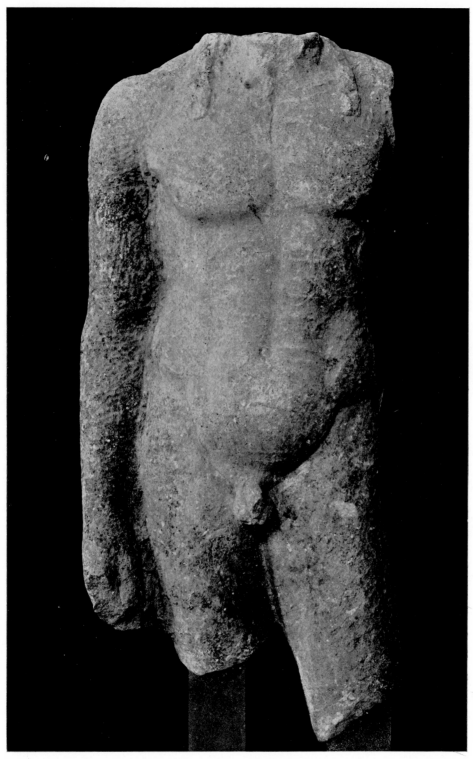

45. TORSO OF A YOUTH. Copy, Roman imperial period, from an original of
the fifth century B.C. Athens, National Museum

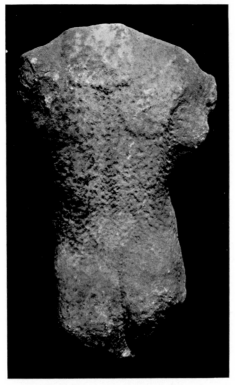

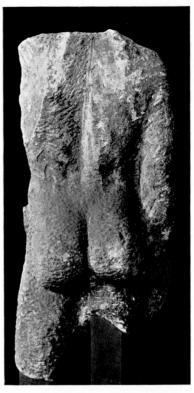

46. MALE TORSO. About 480 B.C.
Museum on Aegina

47. TORSO OF A YOUTH.
Copy, Roman imperial period
from an original of the fifth
century B.C. Athens, National
Museum

be a reproduction of the famous statue of a youth unlacing his sandals. The original, a work of the fourth century B.C., from the School of Lysippus, was certainly a bronze, but was frequently copied in marble during the imperial period. The copyist was given the task of carving a statue which was based entirely upon roundness of form and variety of aspect. He could not divide it simply into two halves, a back and a front, as was done in the case of the torso of a youth. To help himself, he made a quantity of graphic incisions, so dissecting the figure as in an anatomical study. Finally all the details were neatly linked up and polished. The modelling in such a case is entirely superficial and correspondingly uninteresting. Nothing can conceal the fact that a copy of this nature did

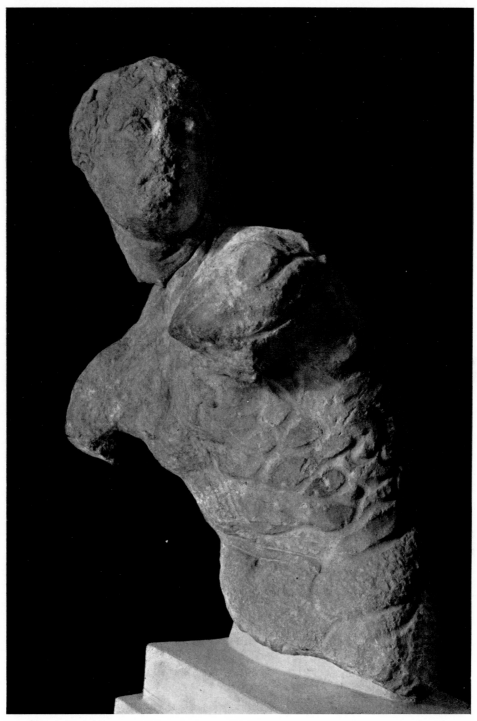

48. TORSO OF AN ATHLETE UNLACING HIS SANDAL. Copy, Roman imperial period, from an original of the fourth century B.C. Athens, Acropolis Museum

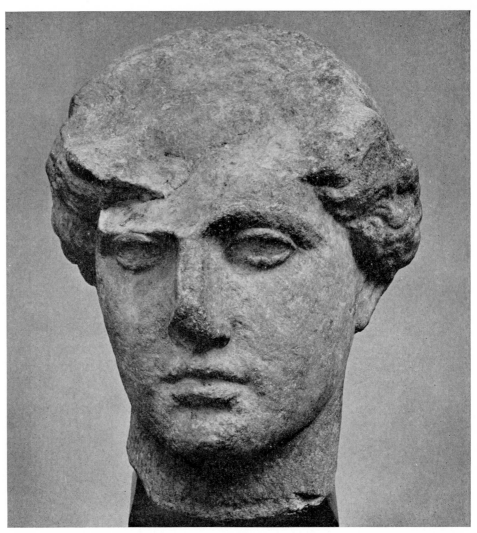

49. HEAD OF A WOMAN, rom Athens. After 440 B.C. Berlin, Museum

not evolve slowly as an organism out of the stone. The sculptor was
doubtless extremely able, a master in the art of stone-cutting. But speed
was also important, and the result was that he could hardly have more
completely renounced the essentials of classical sculpture.

The gap is just as great when we compare an unfinished head from the
classical period with similar works of some centuries later. A beautiful
female head in the Berlin Museum, contemporary with the Parthenon
sculptures, but from which unfortunately the forehead is missing (49),

62

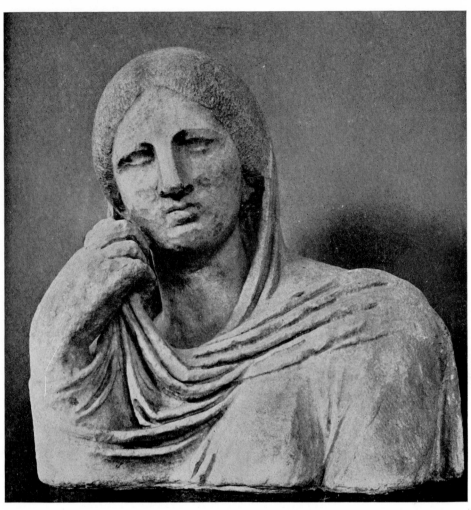

50. FEMALE BUST, from the Island of Rheneia. First century B.C.
Athens, National Museum

was abandoned at the very stage when the artist was about to polish the
surface to a smooth finish with emery and pumice. There are clear traces
of fine point work beneath the chin, and the surface of the face is still
rough, but indications of smoothing are apparent everywhere. There is
no sign anywhere of a flat chisel or rasp having been used. The smoothing
of the surface was carried out in this case, as in almost all Greek pieces,
with emery and pumice rubbed over the fine point work. A female bust
(50) of the first century B.C., now in the Athens National Museum, which

63

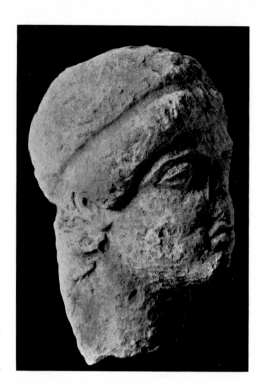

51. HEAD OF A YOUTH.
Roman imperial period.
Athens, National Museum

comes from Rheneia and had probably been intended as a grave orna-
ment, produces an entirely different impression. The face and hand have
been roughed out with the flat chisel in broad, harsh strokes; all the
planes, especially about the eyes and the nose, are sharply differentiated.
Only the hair and drapery bear traces of the claw chisel, the deep folds
and the grooves between the fingers have been cut with a running drill.
The same impression is gained from a youthful head (51) which was
found beside the Enneakrunos on the western slope of the Acropolis and
is also in the National Museum at Athens. The nose has been broken off,
the left cheek and the hair on the left side of the head have also been
severely damaged. A rectangular fragment is missing from the mass of
hair above the centre of the forehead, where there may originally have
been a boss. A deep groove for a fillet has been cut through the thick
masses of hair. This piece has been irregularly and harshly carved, a fault
due partly, no doubt, to the poor quality of the marble, which shows a
tendency to flake off. The only sign of point work is found on the hair,

64

particularly at the back. Otherwise the whole head has been carved with long strokes of the flat and with the bull-nosed chisel. Round the left eye, work had reached an advanced stage, and this area had been almost completely smoothed. The coarse style of work makes it certain that this piece dates from the Roman imperial period.

The difference between Greek point work followed by smoothing with pumice and the far more summary flat chisel modelling of later copies is readily discernible even in finished sculptures. This becomes evident if we compare two heads from the west pediment of the Temple of Zeus at Olympia. The youthful Lapith head (38) is a Greek original, worked with a point and then smoothed by rubbing with a soft stone. We can see how even the delicate planes of the eyelids and eyebrows have been given a resilient, rounded softness, and the whole face here has the large organic forms of a vigorous, young nature. The head of an old woman (39), a replacement in the same pediment, was made in the days of imperial Rome. Perhaps the original was precipitated from the pediment by an earthquake or by lightning, and had to be replaced with a copy. Work with the flat chisel has in this instance resulted in shallowness, in flabby lack of expression. Many of the smaller individual forms are awkwardly juxtaposed, while the effect of the eye sections is unendurably harsh and abrupt. This is true also of other heads of younger persons which were made at the same time. These differences are also immediately apparent in the two lion-head waterspouts (52, 53) from the Temple of Zeus at Olympia, when the rich forms of the original work are compared with the flat, inadequate replacement. In order to bring out this contrast, one of these original lion heads of the fifth century B.C. was exhibited alongside a later copy in the small architectural room of the Berlin Pergamon Museum.

The real significance of the early Greek method of evolving a figure gradually out of the stone layer by layer, using no other tool than the point, is brought home to the full when we learn how long a Greek artist was engaged upon one of his statues. Inscriptions prove that he must have had a great deal of patience and must have worked hard over a long period in order to reach the ultimate stage of balance and finish.

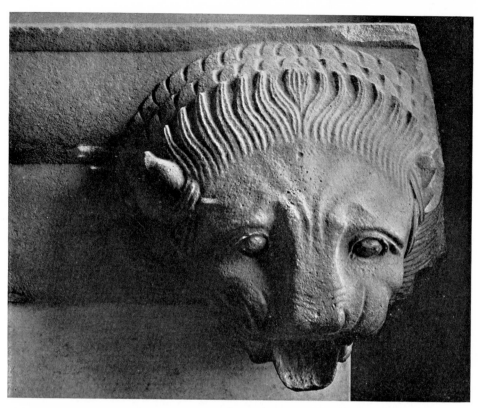

52. LION-HEAD WATERSPOUT, from the Temple of Zeus at Olympia.
About 460 B.C. Berlin, Pergamon Museum

Parts of the building accounts for the Erechtheion frieze on the Acropolis at Athens, which was created about 420 B.C., have survived, and enable us to draw some exact conclusions in regard to these questions. The figures of this frieze were worked individually, they are almost three-dimensional and were placed against a background of dark Eleusinian marble on the architrave in front of the frieze panels of the temple. The bill, which has been preserved in an inscription, records these figures and groups individually, as well as their prices. The sculptor was paid 120 drachmae for a youth writing and a man standing beside him. This sum did not include the preparation of the model. The group, which once cost 120 drachmae, has fortunately been preserved almost intact (54). It was originally about 58 cm. (23 in.) high. Since the highest daily wage at

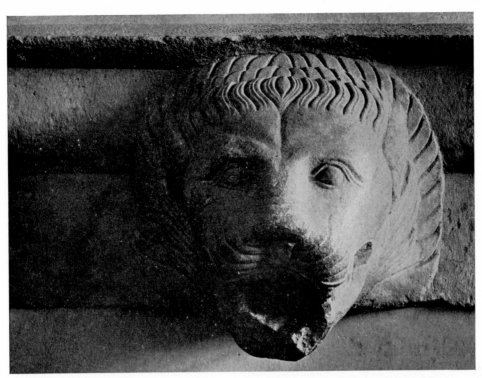

53. LION-HEAD WATERSPOUT, from the Temple of Zeus at Olympia.
Copy, Roman imperial period. Berlin, Pergamon Museum

that period was one drachma, and even the architect in charge did
not receive more, the work must have taken at least four months.
Certainly no deductions for the cost of material need be made, for the
marble was supplied and is mentioned in another part of the inscription;
in any case, such a small piece would have cost very little in Greece. But
the sum of 120 drachmae probably implies a far longer period of work
than four months. We know that not every assistant is mentioned by
name in bills of this kind, but only those sculptors who had large studios
and employed many assistants. Certainly the assistants will not have
earned anything like one drachma a day, as did the responsible architect,
but far less, and therefore the sum of 120 drachmae, even if a profit for
the master is included, must have covered a far longer period than four
months. Thus inscriptions of this nature can, on occasion, become a living
reality for us. It is far from being unimportant whether a sculptor spent

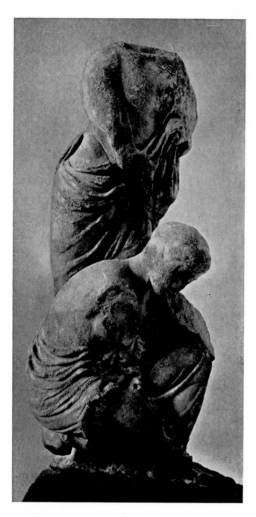

54. GROUP OF TWO MEN,
one standing and one kneeling in front
of him. From the Erechtheion frieze.
Last quarter of the fifth century B.C.
Athens, Acropolis Museum

ten or sixty upon one figure in a frieze. For these figures reflect an evaluation of artistic work which must have influenced the whole outlook.

The same is true of the models which the Greek sculptor prepared for his marble sculpture in the classical period. Doubtless their size was identical to the work in stone, and they were finished down to the smallest detail. This is proved by another building inscription, found on the Temple of Asklepios in Epidauros. For supplying models of the pedimental groups, together with designs for the acroteria of the temple, the sculptor Timotheos, in the fourth century B.C., was paid 900 drachmae, and since the chief architect received, as at the Erechtheion, one drachma a day, this

68

total of 900 drachmae represents one man's work over a period of nearly two and a half years. Timotheos did not take two years to complete the work, because he must have employed assistants. But this is scarcely relevant here. What we are concerned with is the amount of work revealed by the payment of 900 drachmae. It is inconceivable that the sculptor would have received two and a half years' payment had he supplied only small preliminary models requiring little time to make.

Up to this point we have discussed little but sculpture in the round. We must now draw some parallels with relief sculpture, which in many respects follows its own rules. Only very high relief differs hardly at all from three-dimensional sculpture of the same period. It may be taken for granted, for instance, that the metopes of the Temple of Zeus at Olympia or of the Parthenon received the same technical treatment as the pediment sculptures. This is true also of Hellenistic high relief, which is technically very similar to three-dimensional sculpture.

Considerable parts of the Telephos frieze of Pergamon have remained unfinished; they are particularly suitable for comparison with the sculptures from the island of Rheneia already mentioned. A relief panel (55) represents workers engaged upon the construction of the shell of a boat, with a hatch, in which Auge, the mother of Telephos, is to be exposed on the sea. The bowed, heavily veiled, seated woman, above the boat-building scene, is the king's daughter, Auge herself. To the left is a group of her companions. The upper half of the panel, where the work is more advanced, has been smoothed almost entirely with a flat chisel. The deep folds of the seated woman's draperies were worked with a running drill. Large portions of the lower half of the relief bear regular traces of a claw chisel, as, for instance, the whole shell of the boat, the right leg of the man in the background, and the back of the worker in the foreground; his left arm and head have been smoothed with a flat and with a bull-nosed chisel. The left leg has been completely finished and smoothed. The final layers on the Telephos frieze were removed with a claw chisel, a flat chisel and a bull-nosed chisel, as in the case of the sculptures from Rheneia. The running drill was also called into service. The clarity of the design and the harmony between the masses in this relief of the second century B.C. leave nothing to be desired at this stage of the work, and make it almost superior to the Rheneia statue of a youth.

In low relief work, the Greek sculptor proceeded along lines fundamentally different from those of a modern studio. When a modern artist wishes to model a relief, he begins by taking a wooden board on which he places his clay. This he proceeds to work quite freely. When the clay

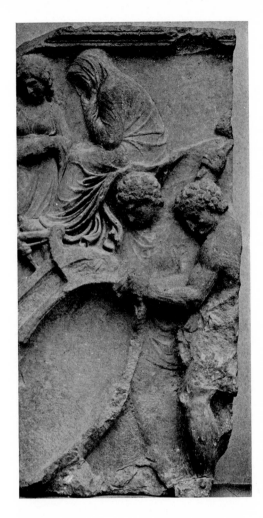

55. RELIEF FROM THE
TELEPHOS FRIEZE, Pergamon.
Second century B.C.
Berlin, Pergamon Museum

relief is ready, it is cast in plaster and is then translated into stone by the usual methods of measurement. A Greek sculptor adopted a system diametrically opposite to this one. His relief was never raised from a flat surface. He sketched out his figures upon a marble panel and then cut away the background round the outline.

The British Museum possesses a relief (56), 36 cm. ($14\frac{1}{4}$ in.) high and 30 cm. ($11\frac{3}{4}$ in.) across, from the sixth century B.C., which was found in the sanctuary of Aphrodite at Naukratis. It represents a warrior with a Corinthian helmet and spear. We are shown the inner side of the round shield on his left arm. Since the figures show no modelling, no drawing or rounding off, only the greaves being lightly incised, this work might

71

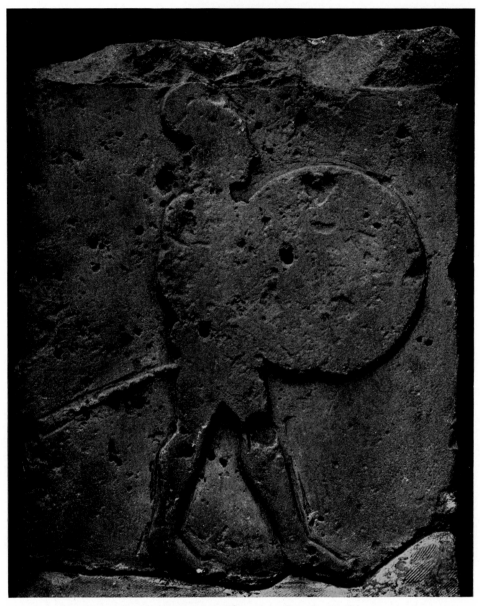

56. RELIEF WITH WARRIOR, from Naukratis. Sixth century B.C.
London, British Museum

be thought to be unfinished. This would seem unlikely, however, for the
surface has been adequately smoothed. What we miss today was pre-
sumably added by the artist by means of colouring; unfortunately this
has completely disappeared. An unfinished piece from the frieze of the

72

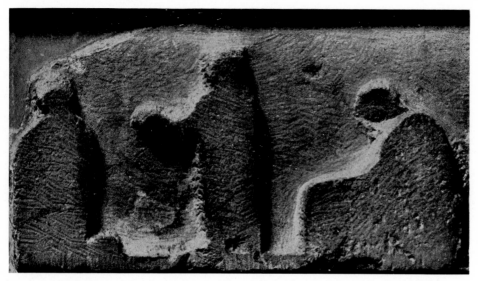

Nereid monument (57), of the end of the fifth century B.C., gives the same impression. The figures look like wooden fretwork against the flat background — another instance where the sculptor incised the outlines in the stone and then cut away the background. The next step would have been the rounding and modelling within the figures themselves. But even in a finished state the figures would have stood out in isolation against the background. In a relief of this kind, however much the background may vary in depth, the figures inevitably occupy the front plane of the marble slab, and all the highest points are at the same level. Modern reliefs are exactly the opposite, with the background plane remaining fixed, and the representation taken to any height that may be desired.

The Greek sculptor is faced with a much more difficult problem where his relief necessitates several different planes, as in the Parthenon frieze, in which the young Athenian horsemen are shown actually riding four abreast. He could not in this case, as in the Nereid monument, cut straight down to the background, but had to work through gradually in layers and renew his sketch each time for every successive layer. In order to

73

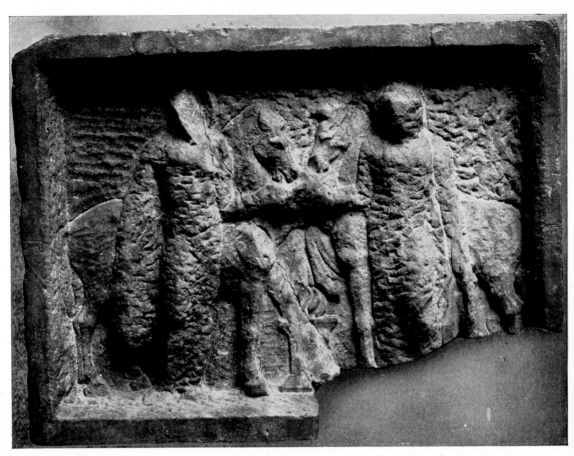

58. VOTIVE RELIEF WITH THE TWO DIOSCURI, Athens. Fourth century B.C.
Berlin Museum

keep the various parts clearly separated while at work, he used different
tools where possible. An unfinished Attic relief of the fourth century
B.C. (58), in the Berlin Museum, shows this process particularly clearly.
On either side of a burning altar stand two male figures wearing small
capes. Each leads a horse by the bridle; the two Dioscuri must be
intended.

The relief is framed by a smooth border, part of the remaining surface
of the marble panel. The two male figures and the background in the
upper right hand corner and in the centre part around the horses' heads
have been worked with a point. The horses' bodies and the altar are on a
lower plane. These parts have been carved out with a flat chisel and the

74

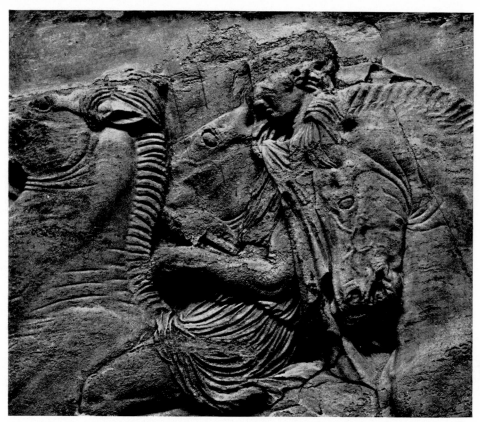

59. HORSEMAN, from the Parthenon frieze. About 440 B.C.
London, British Museum

outlines have at the same time been sharply redefined. It is especially
notable that the head of the man on the right projects as far as the plane of
the smoothed frame. A small section of the original surface of the marble
panel remains on the front part of the face. The sculptor undoubtedly left
this fragment on purpose in order to retain the relation with the highest
plane of the relief. The sureness of touch and the clarity with which this
relief has been evolved out of the stone are truly admirable. The postures
of the two men, the slight differences in their attitudes, have been made
clear even at this early stage by means of a few strokes of the chisel. The
main difference between this piece and sculpture in the round is that in a
relief the sculptor does not limit himself to point work to the same
extent, but frequently uses a flat chisel or a bull-nosed chisel.

75

Better than any description, a small section of the Parthenon frieze itself (59) will convey an idea of the ability and versatility of Greek sculptors. Most strangely concealed on this panel, as Pernice pointed out many years ago, is a horse's head. For the horseman's cloak has been formed out of what had been a sketch of a horse's head, and whereas in the case of the other horsemen, who wear identical clothing, the manner and place of the cloak's fastening are clearly discernible, in this one instance the ends merge indistinctly and, moreover, do not join on the breast, but are pushed far forward. Again, behind the young man's head, the cloak extends in a peculiar way along the horse's mane, yet it does not actually flutter freely behind him. Having made the first sketch, the sculptor of this frieze panel in a bold sweep carried the horse's mane too far forward, thus throwing the animal's forequarters out of proportion. When he discovered his error the panel was already in place upon the building. He therefore simply changed the horse's head into a cloak. The transformation was so successful that it can only be perceived upon close observation.

The last Greek relief which we intend to discuss (60) takes us back to where we began, for it reminds us immediately of Mynno's grave relief, and the reminder is exact. The small, low relief, also made in Athens in the decades following the completion of the Parthenon frieze, is hardly more than a sketch; it may even have come from the same studio which produced the Mynno stele. On one of the largest Attic grave vases in Athens, a lightly engraved scene of a seated woman with a girl behind her, which lacks any relation to the central theme, has been inserted into a somewhat uninteresting and pointless relief, from which a horse's tail and the rim of a shield had first been cut away.

The rendering of the drapery is almost haphazard, like the surface of a choppy sea; the channels, made with a fine bull-nosed or flat chisel, are now close together, now wide and shallow, the whole complex structure of folds being designed to catch the finest nuances of light and shade so that this delicate relief gives almost the same impression as a charcoal drawing. It is clear that this group of girls was first drawn as a whole in

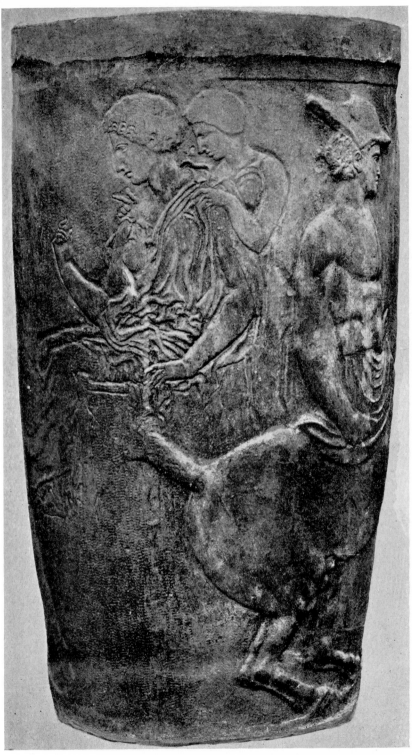

60. ATTIC GRAVE VASE. After 440 B.C. Athens, National Museum

firm outline, the artist then going on to define the details, always keeping them within the framework of the overall effect, of which all else was a part and to which all else was subordinated. The fact that this sketch was made upon a finished grave vase must be attributed to the artist's whim. The product of a sudden inspiration, it was probably no longer visible when the vase was set up, because it had been painted over.

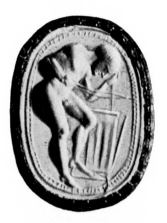

61. ARTISAN USING A RUNNING DRILL.
Impression from a gem. London, British Museum

SEVERAL unfinished sculptures from later centuries indicate that the paths of development in Italy and Germany necessarily followed along the same lines as those taken by the sculptors of antiquity, and this again finds expression in the technical evolution corresponding to the respective levels of stylistic attainment. Thus the unfinished sculptures of the thirteenth and fourteenth centuries often recall the methods adopted by early Greek sculptors, Michelangelo's works correspond technically, more or less, to those of Greek Hellenistic artists, and the sculptors of the late Renaissance work in exactly the same fashion as the artists of imperial Rome. A few samples chosen at random can make this abundantly clear.

In so far as the copying technique so typical of the metropolitan art industry ever reached the Roman provinces, it quickly withered. The complicated process of pointing and measuring and all exaggerated technical niceties became forgotten. There was a natural return to first things and the way was open once again for real sculpture.

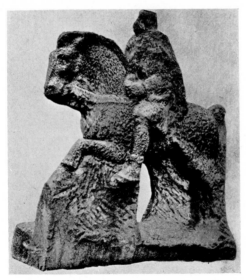

62. RIDER, from Breitfurt an der Blies.
Fourth century A.D.

Two large unfinished Roman stone monuments have been discovered in the Palatinate, the riders of Breitfurt an der Blies (62). They were discovered in 1887 in a filled-in Roman quarry, and now stand on the

79

steps of the Historisches Museum at Speyer; they are 2·85 metres (9 ft. 4 in.) high, and may have been auxiliary figures for a large Roman grave monument which had to be abandoned before completion, or else have been intended for imperial statues to decorate the forum of a town such as Treves or Metz — possibly the emperor Valentinian I (A.D. 364–375) and his son Gratian. They are not very different in their main lines from early Greek sculptures, being carved out with a point from all four sides of a block. They cannot, of course, compare with the clarity of design and consistency in modelling of archaic Greek sculpture. The Opera del Duomo at Orvieto possesses two unfinished but very nearly complete statues of the fourteenth century, a Coronation of the Virgin from the School of Orcagna (63), about 50 cm. (19¾ in.) high, and a seated woman holding a column (64), about 60 cm. (23⅝ in.) high. Both have been carved out of the stone in the round, just like the Olympia sculptures. Every part of the work has reached the same stage, which suggests that the sculptor removed one complete layer at a time from his figure as did the Greeks in the classical period. Michelangelo's Slaves mark another important stage in development, for he adopted the process common in the late Hellenistic period of working from a flat relief through emphatic high relief to sculpture in the round. It should further be noted that, conceptually, it is the master's earliest works that are least akin to reliefs, for in Italian art, as in Greek, the oldest process was that of extracting a three-dimensional sculpture from the matrix.

The development of relief is similar. On a tympanum above a door in the east choir of Naumburg Cathedral there is a small unfinished relief, from the workshop of the Master of Naumberg, which represents Christ between Mary and John the Baptist (65). The work was carried out progressively from left to right. The kneeling figure of St John and the lower part of Christ's body have only been sketched out with the point, but Mary on the left, and the head and upper part of Christ have been smoothed with a flat chisel. It is interesting to observe that this work of the thirteenth century, which is not in itself important, but belongs nevertheless to the great age of German sculpture, was fashioned out of

63. THE CORONATION OF THE VIRGIN. School of Orcagna.
Fourteenth century. Orvieto, Opera del Duomo

the stone without the use of pointing and, as in sculptures of the early
Greek period, only a punch was used. Throughout the larger masses
remain coherent, and from these all the detail evolves organically. The
only difference in technique between the sculpture and a piece from the
early period of Greek art is that in Naumburg the smoothing has been
done with a flat chisel, whereas the Greek smoothed his sculpture by
rubbing. The reason for this may lie in the difference in material, and it
carries little weight against the fact that two works correspond almost
entirely in technique as a whole.

81

64. WOMAN WITH COLUMN. School of Orcagna. Fourteenth century.
Orvieto, Opera del Duomo

The same may be said of an unfinished relief panel in white marble
which is now in the Museum at Pisa (66). It dates from the first half of

65. TYMPANUM RELIEF: CHRIST BETWEEN THE VIRGIN AND ST. JOHN.
East choir, Naumburg Cathedral. Thirteenth century

the fourteenth century, and is 69 cm. high (2 ft. 3 in.) high and 71 cm.
(2 ft. 4 in.) wide. The upper left-hand portion represents the Annuncia-
tion, below we see the Birth of Christ, and on the right the Adoration
of the Shepherds. It was evidently intended to be a panel for a pulpit,
as may be proved by a comparison with the relief decoration on the
pulpit in Pisa Cathedral by Giovanni Pisano, and the pulpit of San
Michele in Borgo made by Tino da Camaino in his early period. In this
case, too, as in the Greek relief, the design was first traced upon the marble
panel, and the outline then deepened together with the relief ground, the
masses of the individual figures gradually emerging from the stone with-
out the use of the process of pointing. But a work which once stood in
the Kaiser Friedrich Museum in Berlin (67) indicates how different an
unfinished relief may appear. This is a relief without a background,
representing an allegory of Faith, and is attributed to Mino da Fiesole.
Compared with the reliefs from Naumburg and Pisa, it seems thin and
feeble, because the unfinished portions are unimaginatively conceived,
and from the beginning there has been no attempt at any organic

83

66. ANNUNCIATION, NATIVITY AND ADORATION OF THE SHEPHERDS.
Relief, early fourteenth century. Pisa Museum

development of the whole. The head and throat are finished except for polishing, but the rest is only very roughly carved. At the same time the whole lost its unity as work went on, a fault which could not later be made good.

OUR examination of unfinished sculptures from various periods of the art of antiquity would be profitable even if it were to give us only some insight into the many technical processes which were once a living possession of the sculptors' workshops, being handed down from masters to pupils and assistants, and thus continually developing like all living

84

67. ALLEGORY OF FAITH. Relief,
attributed to Mino de Fiesole (1431–84).
Berlin, Kaiser Friedrich Museum

things; for in this way many questions relating to the plastic view of
form can be better analysed, and sometimes more profoundly elucidated,
than through complex theoretical discussion.

But such knowledge can also prove to be a useful aid in quite simple matters of criticism. Greek architectural remains from the classical period can now be distinguished with certainty from Roman ones because the technical details of the art of building have been thoroughly and professionally investigated by architects. On the other hand, one sometimes encounters the greatest uncertainty in deciding whether a piece of ancient sculpture is a Greek original or a copy made in the days of imperial Rome. The best example is the famous Praxitelean Hermes, which was considered by the excavators of Olympia to be a Hellenistic work, as we learn from their journals. For fifty years it was regarded as the most important Greek original of the fourth century B.C., but according to the technical findings from the unfinished back, it cannot have been carved before the second century B.C., and hence cannot have been the work of the great Praxiteles. Formerly, recourse was seldom had to technical criteria in doubtful cases of this kind; the argument usually turned upon artistic merit, was conducted subjectively and nearly always remained inconclusive.

Whether an artist today can profit by this technical knowledge is a question which can only be put with some reserve. The answer depends entirely upon his attitude towards ancient art. If he feels within himself any sympathy with Greek plastic art he can learn something from every good Greek sculpture, and to a sculptor, in particular, it will be of small significance whether the piece is finished or no. With his knowledge of sculptural technique he will certainly examine the unfinished pieces with a professional eye, evaluating them in relation to his own work. It will obviously never occur to him to adopt Greek technical processes wholesale, because he knows better than anyone else that, like all his artistic forebears, he must himself develop the technique best adapted to his own art.